IMAGES
of America

PERRY HALL
MANSION

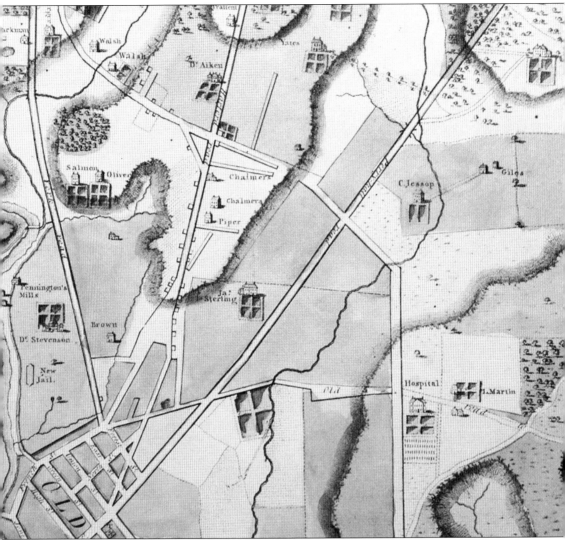

The first residents of Perry Hall Mansion, Harry Dorsey and Prudence Carnan Gough (the latter of the Ridgely family), were well known throughout Colonial Maryland. Their prominence was such that this 1801 map, "Plan of the City and Environs of Baltimore," referred to today's Bel Air Road (US Route 1) as Perry Hall Road, alternately noted as Gough's Road on some other maps from that time. (Maryland State Archives.)

On the Cover: In October 1936, during the residency of William and Eva Plummer, photographer E.H. Pickering visited Perry Hall Mansion for the Historic American Buildings Survey (HABS). This New Deal program was created to offer employment to architects, draftsmen, and photographers left jobless by the Great Depression. Individuals employed by HABS documented a representative sampling of the nation's architectural heritage. (Library of Congress Historic American Buildings Survey, photograph by E.H. Pickering.)

IMAGES
of America

PERRY HALL MANSION

Sean Kief and Jeffrey Smith

ARCADIA
PUBLISHING

Published by Arcadia Publishing
Charleston, South Carolina

Printed in the United States of America

Library of Congress Control Number: 2012948932

For all general information, please contact Arcadia Publishing:
Telephone 843-853-2070
Fax 843-853-0044
E-mail sales@arcadiapublishing.com
For customer service and orders:
Toll-Free 1-888-313-2665

Visit us on the Internet at www.arcadiapublishing.com

*To our families—Lynn, Maya, Jake, and Lukas Kief,
and Patricia and Alex Smith—for their steadfast
support during the preparation of this book.*

CONTENTS

ACKNOWLEDGMENTS

The authors are deeply indebted to so many people whose interest in historical preservation generally—and Perry Hall Mansion in particular—were invaluable in this creative effort. To our colleagues on the board of directors of Historic Perry Hall Mansion Inc., Colleen Bowers, Dean Foreman, Dale Kief, Laura Kimball, Sylvia Louwers-Sackleh, Tim Kosiba, Glenn Spammer, and Wayne Schaumburg, we offer our profound thanks for your continued hard work and dedication to the preservation and adaptive reuse of Perry Hall Mansion. A number of individuals well-versed in local history, including Chris Kintzel, registrar of artistic property for the Maryland State Archives; Mark Letzer, chief development officer for the Maryland Historical Society; Richard Rogers, historian for Camp Chapel United Methodist Church; Robert Shindell, director of the Lovely Lane Church Museum and Archives; and Jane Woltereck, site director at Mount Clare Museum House, graciously guided us through their holdings related to Perry Hall Mansion. Other individuals, such as Zach Dixon, Les Horn, Selma Kahl, David Marks, Loretta Ruttkowski, Tim Sheridan, Carlene Silhanek, and Linda Wilson, also made valuable contributions to the images that appear within this volume. Most significantly, the authors are deeply thankful for the assistance of surviving residents of Perry Hall Mansion and their descendents, who generously provided stories and images. Dale Kief, Casey Phillips, Marion Porter, Lou and Loloa Rohe, and Ken Smith (descendants of the Dunty family), Sybilla Kramer and Markus Plummer (members of the Plummer family), Diana Smith Mister (a member of the Gordon Smith family), Hank and Reed Kaestner (members of the Kaestner family), and others who wish to remain unnamed, opened their family albums and shared their recollections of times at Perry Hall Mansion with both of us. Images within this volume appear courtesy of a variety of public and private sources, which are noted following each caption.

INTRODUCTION

Perry Hall Mansion has long been considered one of the most historically significant residences in Baltimore County, Maryland. During its near 250-year history, the mansion's place in the surrounding community has consistently evolved from early years as the country estate of a Colonial merchant family, to the home of local farm families, and in recent times, a center of suburban growth in northeastern Baltimore County.

The land on which Perry Hall Mansion stands was originally called "The Adventure." In 1684, Charles Calvert, the third Lord Baltimore, granted George Lingan a patent certificate for this tract, located on the south side of the great falls of the Gunpowder River. By 1765, the property had been acquired by Corbin Lee, an ironmaster of the locally prominent Nottingham Company, which had its forge just over two miles away from the site.

Lee began building the mansion in 1773 but died in December of that year. The main section of the house—excluding the portico, which was added later—mimics Virginia's Berkeley Plantation, the birthplace of Benjamin Harrison V (governor of Virginia, signer of the Declaration of Independence, and direct ancestor to two presidents). Both residences were designed symmetrically, each with a central entrance door flanked by two pairs of windows, five windows on the second story, and three dormer windows above.

Lee left behind a widow but no children. The still uncompleted home was offered for sale in mid-1774, and was ultimately acquired by Harry Dorsey Gough (1745–1808) and his wife Prudence (1755–1822). At age 21, Gough had the extraordinary luck of inheriting more than £70,000, thereby giving him access to the money necessary for this substantial purchase. At the time of its sale to the Gough family, the total acreage of the property was listed as 1,129.

The Goughs promptly settled in and immediately began work to finish construction of the house. By approximately 1784, they had completed the addition of two matching outer wings attached to the main portion of the house. They named their home Perry Hall in honor of the Gough family's ancestral residence in Staffordshire, England.

Both Harry Dorsey and Prudence Gough were to become important figures in Colonial Maryland. Harry Gough served as the first president of the Society for the Encouragement and Improvement of Agriculture in Maryland in 1786. He was among the first in Maryland to import purebred livestock, which included English cattle and workhorses. As time progressed, Gough added Persian broad-tailed sheep, with mutton from these being given as a gift to Pres. George Washington. In later years, Gough served as a member of the Maryland House of Delegates from 1790 to 1793. He also served on the board of trustees for one of Baltimore's first orphanages.

Prudence Carnan Gough was a member of one of Colonial Maryland's most important families. Her maternal grandfather, Col. Charles Ridgely (c. 1702–1772), received a grant for more than 10,000 acres of land, on which Hampton House was ultimately built (in today's Towson, Maryland). Prudence Carnan Gough's younger brother Charles Carnan Ridgely (1760–1829) became the

15th governor of Maryland in 1815. She married Harry Dorsey Gough on May 2, 1771. Hampton House has been frequently referred to as the sister house to Perry Hall.

Prudence Gough was one of the most prominent Colonial Marylanders to take an interest in the burgeoning Methodist Church in America. As the Methodist movement swept the American colonies in the 1770s, its direct, emotional style attracted not only slaves and backcountry families, but also members of more well-to-do families. Early accounts, principally from the journals of Bishop Francis Asbury (one of the first two leaders of the Methodist Church in America), make reference to Prudence Gough's attendance at Methodist services and her sincere interest in helping to spread word of this new faith tradition.

Unfortunately for Prudence, her husband's interests were of a very different sort. For the first four years of their marriage, Harry Dorsey Gough lived the life of a country squire, hosting boisterous parties at their home. However, this changed in 1775, when Gough and several friends attended a Methodist service in Baltimore. Gough's friends were probably more interested in ridiculing Methodism when they attended that service, but Gough was clearly moved by what he saw. Returning to the mansion, he reportedly told Prudence, "I will never hinder you again from hearing the Methodists." Harry Gough subsequently rode throughout his estate that evening, stopping when he heard singing at one of the slave cabins. There, he saw the poorest in society offering thanksgiving for their blessings in life.

After their conversion to Methodism, the Goughs added a chapel to the east wing of Perry Hall Mansion. Each day, the bell of this chapel, the first ever to adorn a Methodist chapel in the United States, was rung for morning and evening prayer, attended by the Goughs and their slaves. Bishop Francis Asbury's journal described such a service as follows: "Mrs. Gough read a chapter in the Bible, gave out a hymn . . . after which she would engage in prayer." Prudence Gough's sole sister also converted to Methodism, as did many other members of her family.

Harry Dorsey Gough died in Baltimore City on May 8, 1808. More than 2,000 people attended his funeral. Presiding over the funeral ceremony, Bishop Asbury described his departed friend as "a man much respected and beloved . . . his charities were as numerous as proper objects to a Christian were likely to make them." The funeral was held in Baltimore, and his body was taken to the Perry Hall estate for burial.

After her husband's death, Prudence Gough inherited a life interest in the estate, which was to pass to her daughter, Sophia Gough Carroll (1772–1816), in trust for her second son, Harry Dorsey Gough Carroll (1793–1866). Prudence survived her husband by 14 years, dying on June 23, 1822. Methodist Bishop Thomas Coke described Prudence as "a precious woman of fine sense," while Asbury confided in his journal that she "hath been like my faithful daughter."

Following the death of Prudence Gough, ownership of the mansion transferred to her grandson, Harry Dorsey Gough Carroll. He then came to Perry Hall with his wife, Eliza Ridgely Carroll (1797–1828). During the Carroll tenure, Perry Hall suffered a disastrous fire on Friday, December 13, 1839, which is referenced in a short account in the *Baltimore Sun* newspaper. This disaster consumed two bays of the main house and the east wing of the mansion. Account books from 1840 to 1844 show Gough Carroll making enormous purchases of plank, lath, nails, window glass, and paint for the dwelling.

The family began the process of rebuilding by repairing and expanding the surviving west wing. As a consequence of the complete loss of the east wing, a new second story was added to the west in order to recover a portion of the lost living space. Initial charges associated with this work occurred during March 1840, with the wing construction appearing to be substantially complete by January of the following year. Most of the laborers for the project (carpenters, masons, bricklayers, plasterers, and painters) were brought from Baltimore City, where the Gough Carrolls had their principal residence.

Charges in the account books noted that work on the main house began in November 1840, with construction supplies purchased for use in the following year's season: lumber, including flooring from North Carolina, and French yellow ochre, a pigment made from naturally tinted clay. Initially, work proceeded at a rapid pace, with labor costs associated with the installation of

a tin roof appearing for September 1841. Lightning rods were also installed at the same time as the tin roof, perhaps offering a clue as to how the original fire may have started.

Few construction-related purchases were noted for the years 1842 and 1843, but work proceeded in earnest in 1844 and reconstruction was likely complete by the end of that year. A number of the most prominent features of today's Perry Hall Mansion were put in place at this time, including the modest maple banister and spindles for the staircase, and the marble mantles (costing $120) present in the two rooms off of the Great Hall.

In 1847, Gough Carroll had the property resurveyed and re-patented in the Maryland Land Office under the name Perry Hall. The number of acres on the estate was given as 1,344. In 1852, Gough Carroll sold the mansion and 894 acres to Philadelphian William Meredith for the sum of $22,000. For the next 35 years, persons with Philadelphia connections held the house and grounds. Much of the land associated with the mansion was subdivided and sold to other investors who then sold portions of the estate to families that built dozens of farms. Many of these were immigrant families from Germany, and the area became known as Germantown, a thriving village on the rural outskirts of Baltimore.

In 1888, the Philadelphia heirs of William Meredith and his subsequent partner Eli Slifer sold the mansion and 335 acres of the estate to a Baltimore County resident, William Dunty Sr., who was born in Maryland in 1833. In addition to being a farmer, Dunty also operated the turnpike hotel in Fork, Maryland, and served as the postmaster of that village for many years. On March 12, 1894, Dunty Sr. transferred ownership of the mansion to his son William Dunty Jr., who lived there with his wife, Hannah, and family for the next 22 years. It is probable that Dunty Sr. purchased Perry Hall Mansion to assist his son in establishing a farm of his own. Subsequently, William Dunty Jr. relocated to Bishop's Inn, built about 1813 near the intersection of today's Bel Air and Joppa Roads.

The Dunty family was actively engaged in a variety of commercial endeavors during their tenure at Perry Hall Mansion. In addition to their own farming efforts, the Duntys would lease portions of the mansion grounds to other families who worked as tenant farmers. The Duntys also established a sawmill operation along the banks of the nearby Great Gunpowder Falls River.

In the autumn of 1900, the Dunty family played host to a tour of Methodists, numbering more than 200 persons, led by the Rev. John Goucher. According to an account of the pilgrimage in the *Baltimore Sun*, Dunty took the visitors through the house and also showed them the supposed slave jail on the premises. This was a windowless building with overhead hooks, supposedly for hanging people up during their detainment. In reality, this structure was likely to have been used as a smokehouse by the Goughs and subsequent owners of Perry Hall Mansion.

While the Dunty family ultimately sold Perry Hall Mansion in 1915, the family remained a strong presence within the community for much of the 20th century. Four additional owners held the property until its sale to William and Eva Plummer, who retained the house and remaining 203 acres until 1948. During all of this time, Perry Hall was no longer the center of a great estate, but rather served as a typical farmhouse of the time period.

The Plummer family moved into Perry Hall Mansion in 1924. During their tenure, Perry Hall was a large farm that consisted of a barn and associated outbuildings. Approximately 100 acres of the property were wooded, principally along the steep slope leading down to Great Gunpowder Falls. The remainder of the property consisted of open fields and pasture. Wheat, grain, various vegetables, and related crops provided food for the livestock, the family, and for sale at local farmers' markets.

According to surviving family members, there was no electricity on the farm or in the house until November 1940. During the 1930s, along with farming, William and his brother Joseph acquired a Frick Steel Threshing machine. The Plummer brothers were able to use this device to develop a clientele of farmers for whom they did custom threshing of grain in both Baltimore and Harford Counties. Also during this period, in their travels through the surrounding area, the brothers discovered and purchased an old sawmill. Throughout the 1930s and 1940s, the Plummer brothers operated this sawmill, originally powered by gasoline engines and later by electric engines.

Successive owners of the mansion after 1948 include George Roy and Ella Bryson (1948), John and Mary Gontrum (1950), Gordon and Katherine Smith (1950), and Benjamin and Mabel Kaestner (1953). This progression of owners, many of whom did not actually live in the house for extended periods of time, took their toll on the property. Moreover, the actual amount of land associated with Perry Hall Mansion had become much diminished over the years. When selling the mansion and 23.5 acres of land in 1950, Judge John Gontrum held onto around 180 acres of property that had been associated with the parcel when he had originally purchased it. He subsequently subdivided this acreage for development into today's Perry Hall Manor residential community.

During the ownership of the Smith family, a series of improvements were undertaken, including the addition of a new kitchen and bath, the construction of a colonnaded semicircular porch attached to the west wing of the residence, and other major repairs to the outside of the home. Gordon Smith made a career of purchasing homes in need of repair and then rehabilitating them in short order, subsequently reselling the finished buildings to new owners. After their marriage, the Smiths moved into and renovated at least 23 houses throughout the Baltimore area. Upon selling the mansion to the Kaestner family, Smith and his family moved into their next project, a large barn on the outskirts of the Perry Hall Mansion property. The Kaestners added to the restoration work of their predecessors by completing a series of cosmetic improvements and interior design work within the mansion.

In 1966, now surrounded by just 3.911 acres, the house was purchased by Thomas and Marjorie Mele, who initiated a year of extensive repair and restoration work prior to moving into the mansion. This work was supervised under the auspices of local architectural firm Hall, Sprinkle, and Ritter, with construction overseen by H.L. Chambers and Company. By the summer of 1969, the completed restoration was featured in the *Baltimore Sunday Sun Magazine*. Later work included the installation of a new wraparound porch in 1976. Also during the Mele years, the mansion was listed in the National Register of Historic Places (1980) and listed as a Baltimore County protected landmark (1999).

After extensive collaboration between the owner, community leaders, and local elected officials, the mansion was purchased by the Baltimore County government in November 2001. The department of recreation and parks oversaw routine maintenance and started the process of renovating the property. To date, a series of significant improvements have been made to the exterior of the structure and interior work has upgraded the plumbing, electrical, and climate control systems. Since 2007, Historic Perry Hall Mansion Inc. has served as the volunteer organization responsible for both the future stewardship of this unique residence as well as the promotion of its use in educating the public about its importance to the history of Maryland.

One

PERRY HALL MANSION'S
EARLY YEARS

On June 16, 1681, Charles Calvert (the third Lord Baltimore) granted George Lingan (1645–1708) of Calvert County a patent for 1,000 acres of land in Baltimore County. Referred to as "The Adventure," this tract was located on the south side of the great falls of Gunpowder River. Perry Hall Mansion would ultimately be built on this property. (Maryland State Archives.)

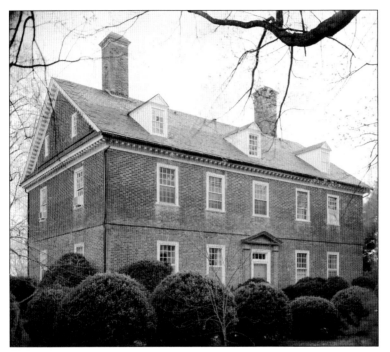

Perry Hall Mansion's design closely resembles that of Berkeley Plantation (pictured), one of the first great estates in America. Located in Charles City County, Virginia, Berkeley Plantation was built by Benjamin Harrison IV and is the ancestral home of two US presidents: William Henry Harrison and Benjamin Harrison. (Library of Congress Historic American Buildings Survey, photograph by Jet Lowe.)

This plat of The Adventure was finalized on December 12, 1774, for the sale of the then unfinished Perry Hall Mansion. Seller Archibald Buchanan placed an April 16, 1774, advertisement in the *Maryland Journal*, stating the availability of the land and "an elegant brick house, 65 by 45." Prominent merchant Harry Dorsey Gough responded within days. (Mount Clare Museum House.)

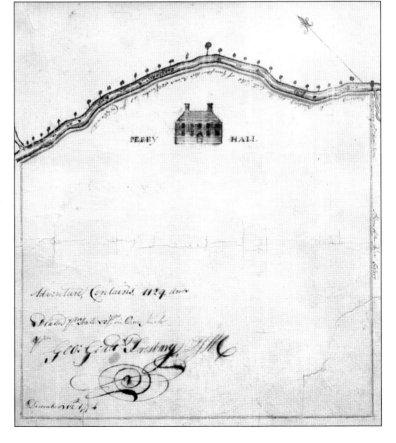

After the death of Corbin Lee, an ironmaster who initiated construction of Perry Hall Mansion, the estate was transferred to Archibald Buchanan in early 1774. In turn, Buchanan sold the unfinished house to Harry Dorsey Gough. As this April 1774 letter indicates, in order to make this £5,000 purchase, Gough required the liquidation of a portion of his extensive holdings and inheritance in England. (Maryland Historical Society.)

Sale of The Adventure was completed on January 16, 1775, as memorialized in this deed. Harry Dorsey Gough promptly changed the estate's name to Perry Hall, in honor of his family's ancestral home in Staffordshire, England. He and his wife Prudence Gough immediately began making improvements to the building, first by completing the interior and then later by adding matching wings onto either side of the house. (Maryland State Archives.)

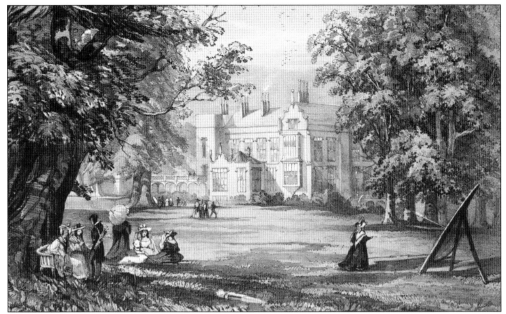

Initial references to the original Perry Hall, shown here, are associated with Sir Henry Gough (1649–1724). Sir Henry served for a number of years in the House of Commons and became the high sheriff of Staffordshire in 1671. Perry Hall was situated on a plot of land surrounded by a moat in an area that would ultimately become the Perry Barr neighborhood in today's Birmingham, England. (Selma Kahl.)

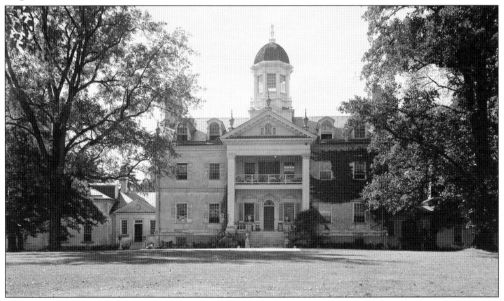

Harry Dorsey and Prudence Carnan Gough also had family ties to the stately residence shown here, Hampton House. Both Goughs were related to the Ridgely family, owners of Hampton. Prudence's mother was Achsah Ridgely Carnan (1729–1778), while Harry was related by virtue of his cousin Rebecca Dorsey's marriage to Captain Charles Ridgely, who started construction of Hampton in 1783. (Library of Congress Historic American Buildings Survey, photograph by E.H. Pickering.)

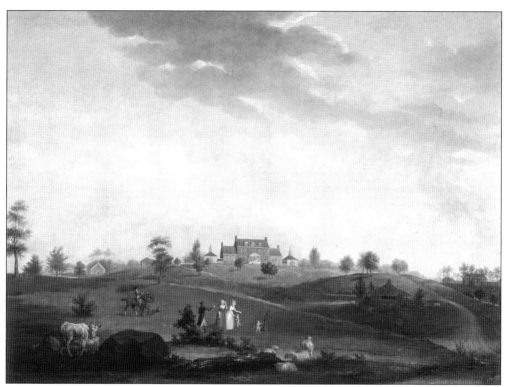

This c. 1795 oil painting is the first known image of Perry Hall Mansion in existence that shows the residence after its completion by the Gough family. Originally attributed to artist Francis Guy, the creator of this detailed work is now identified only as an itinerant English landscapist. (Winterthur Museum, Garden, and Library.)

PERRY-HALL, (Baltimore County) April 4, 1784.
THE Subscriber intending, in the Course of a few Weeks, to settle in some Part of Baltimore-Town, will carry on the Business of COACH, SIGN, HOUSE, LANDSCAPE, and ORNAMENT PAINTING, in the most elegant and newest Method, at the most reasonable Rates.— His Desire to please, he hopes will recommend him to a generous Public, whose Favours will be gratefully acknowledged by JAMES CAMPBELL.
N. B. Any one desirous of employing him, may direct to him—Painter, at Perry-Hall, to the Care of Mr. Daniel Giant, at the Fountain-Inn, Light-Street, Baltimore.

It is quite possible that the artist who created the painting shown above was James Campbell. A gentleman by this name who resided at Perry Hall had placed this advertisement in the April 4, 1784, issue of the *Maryland Journal.* As a consequence of his impending move to Baltimore City, Campbell was then seeking work performing "Coach, Sign, House, Landscape, and Ornament Painting." (Historic Perry Hall Mansion Collection.)

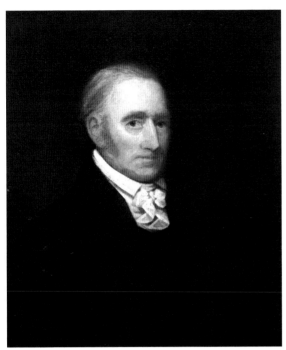

This c. 1800 oil painting attributed to Gilbert Stuart (1755–1828) depicts Harry Dorsey Gough (1745–1808). Harry, the son of Thomas Gough and Sophia Dorsey Gough, was born on January 28, 1745, in Anne Arundel County, Maryland. Young Harry was the first generation of his family to be born in America, as his parents relocated to Maryland from Staffordshire England. (Maryland State Archives.)

Harry Dorsey Gough used his fortune to acquire various properties, many of which were leased to others for investment purposes. Much of Gough's correspondence was directly related to these business activities. A frequent topic of many letters, such as this 1779 example written to attorney James Russell, recounted Gough's attempts to accelerate the liquidation of his English inheritance, notwithstanding difficulties posed by the Revolutionary War. (Maryland Historical Society.)

This c. 1810 oil painting by John Wesley Jarvis (c. 1781–1839) depicts Prudence Carnan Gough (1755–1822). Prudence, the youngest child of John Carnan and Achsah Ridgely, was born on January 16, 1755. After Prudence's death, her niece and namesake Prudence Gough Ridgely Howard, daughter of her brother Gov. Charles Ridgely, would herself become first lady of Maryland from 1831 to 1833 through her marriage to Gov. George Howard. (Mount Clare Museum House.)

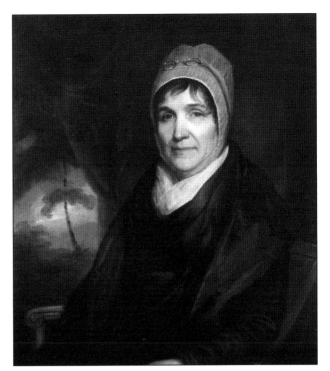

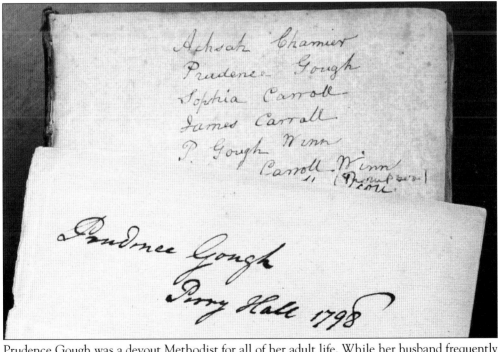

Prudence Gough was a devout Methodist for all of her adult life. While her husband frequently pursued other endeavors, Prudence was consistently dedicated to the cause of spreading the Methodist faith. Both Bishops Francis Asbury and Thomas Coke make frequent reference to her, and her stalwart devotion to the faith, in their letters and journals. This image shows her prayer book, which remains with her descendants. (Private collection.)

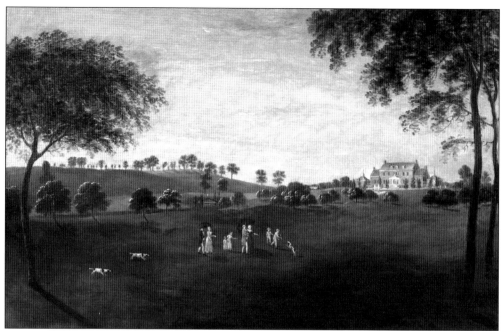

Pictured here are two of three c. 1805 landscapes by artist Francis Guy (1760–1820). Guy was born in England and went on to become one of the most significant early American landscape painters. He chose a career as an artist late in life, teaching himself to paint after the demise of his original business as a silk dyer. These paintings depict two alternate views of the Perry Hall estate. Shown above is how the house looked when viewed from the northwest, while the painting below focuses more on the fields and pastures surrounding the residence. In both paintings, Guy chose to depict figures that we can presume were meant to represent Harry and Prudence Gough and their family members. (Maryland Historical Society.)

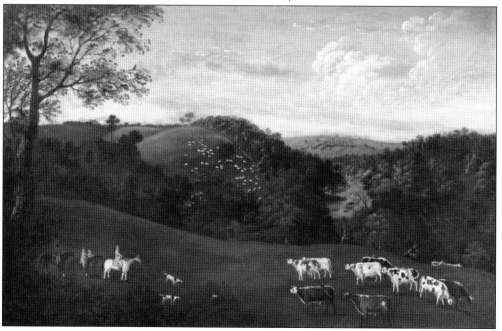

These photographs show an 18th-century English Rococo hot water urn. It is believed that Harry Dorsey Gough bought the urn in London when he went to England to claim his inheritance. The piece was completed about 1767 by Imperial Bushel silversmiths. The image below shows a closer view of the Gough coat of arms, which was featured on the urn. Samuel Kirk made a copy of this urn for Charles Carnan Ridgely about 1829 that is now part of the collection at Hampton National Historic Site. Family lore recounts that Kirk added the heads of Prudence Carnan Gough and the devilish Harry Dorsey Gough to this urn when he made the Ridgely urn. Interestingly, other period urns of this type possess similar engraved features. (Private collection.)

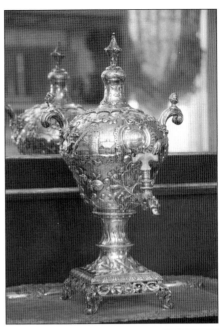

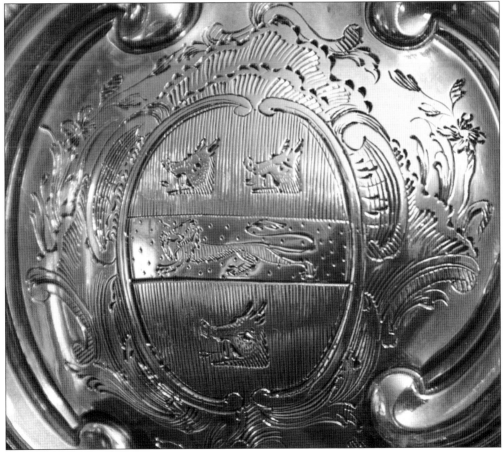

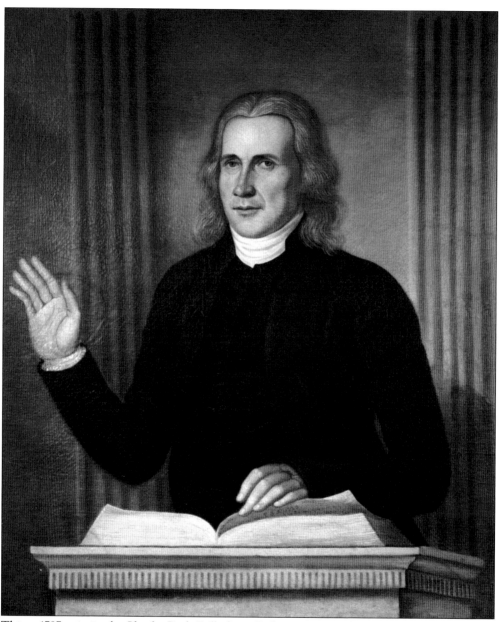

This c. 1797 painting by Charles Peale Polk shows Bishop Francis Asbury (1745–1816), one of two founding bishops of the Methodist Church in the United States. During his ministry, Asbury traveled by horse throughout the countryside, preaching to the masses. It was at one of these sessions in April 1774 that he first preached to Harry Dorsey Gough. Subsequently, the bishop frequently spoke in his journals of his friendship with both Prudence and Harry, and of his many visits to Perry Hall. After one such visit, Asbury remarked, "Perry Hall was the largest dwelling-house I had ever seen, and all its arrangements, within and without, were tasteful and elegant, yet simplicity and utility seemed to be stamped upon the whole. The garden, orchards, and everything else, were delightful indeed, and looked to me like an earthly paradise. But, what pleased me better than anything else, I found a neat chapel attached to the house, with a small cupola and bell, that could be heard all over the farm." (Lovely Lane Church Museum and Archives.)

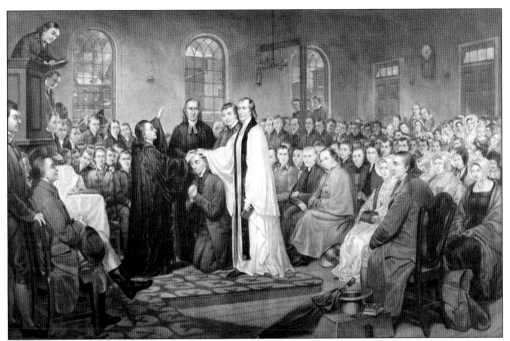

At the closing of the 1784 American Methodist Conference, Francis Asbury was ordained a bishop of the church. This c. 1882 engraving shows the Goughs: Harry (seated at far left, hat in lap) and Prudence (seated right, front row, wearing a white dress/bonnet). Prior to this event, Asbury and Bishop Thomas Coke gathered with other church leaders at Perry Hall Mansion. (Lovely Lane Church Museum and Archives.)

Harry Dorsey and Prudence Gough showed devotion to Methodism in deeds as well as words. Prudence Gough's brother Charles Ridgely donated land not far from Perry Hall Mansion for use by local Methodists. As churchgoers were about to raise funds to construct a church, the Goughs promptly offered to pay for the building of what became Camp Meeting Chapel. This structure stood from 1807 to 1871. (Camp Chapel United Methodist Church.)

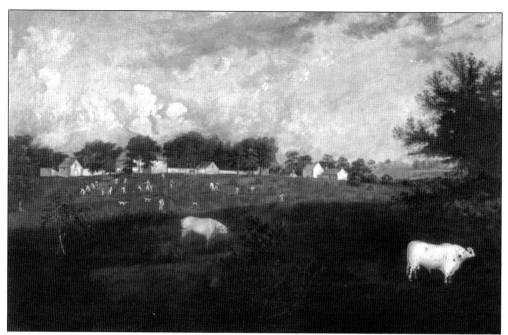

In the third painting of his series, Francis Guy recreated a scene near the slave quarters of the Perry Hall estate. Individuals are shown cutting, raking, and stacking hay. The large structure to the right is likely the overseer's residence, which remains standing today. This painting was later given to a former slave at Perry Hall. (Maryland Historical Society.)

Early leaders of the Methodist Church were staunchly antislavery, believing that the practice was, according to a statement on slavery adopted by the 1780 American Methodist Conference, "contrary to the laws of God, man, and nature, and hurtful to society." On April 25, 1780, the day after Bishop Francis Asbury successfully promoted the above declaration, Harry Dorsey Gough executed this manumission, which freed 45 slaves. (Maryland State Archives.)

This oil painting by Robert Edge Pine (1730–1788) depicts James Maccubin Carroll (1761–1832). James was born on December 8, 1761, and upon the death of his uncle, the barrister Charles Carroll, inherited Mount Clare, the latter's summer residence. After the death of his father-in-law, Harry Dorsey Gough, it appears that James took more of an active role in managing the Perry Hall estate. (Mount Clare Museum House.)

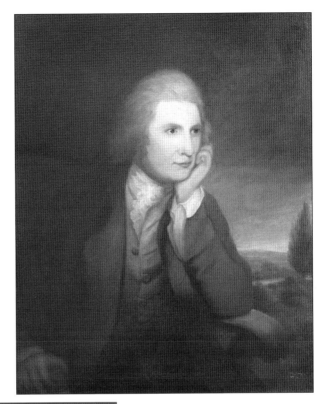

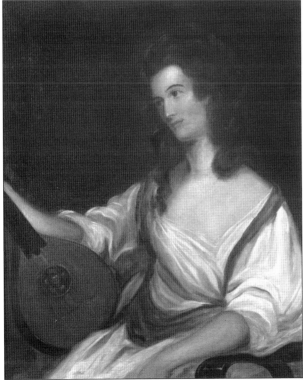

This oil painting by Richard Poultney was modeled after the original by Robert Edge Pine and depicts Sophia Gough Carroll (1772–1816). Sophia, the Goughs' only child, was born on August 7, 1772. She married James Maccubin Carroll in December 1787 and was the mother of four children. Harry Dorsey Gough Carroll, her second son, would ultimately inherit Perry Hall estate. (Mount Clare Museum House.)

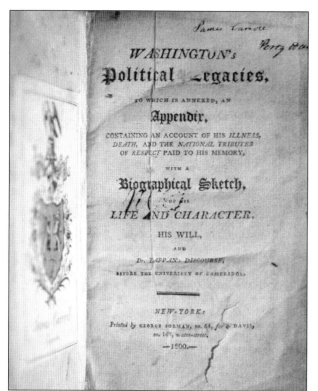

This copy of *Washington's Political Legacies*, printed in 1800, was owned by James Maccubin Carroll, son-in-law to Harry Dorsey and Prudence Gough. The book features the Carroll family book plate on the back of the cover, and is signed "James Carroll Perry Hall," which would seem to indicate that he resided at the mansion with his wife Sophia Gough Carroll at some point. (Mark Letzer.)

·A· Distillery and Orchards.

The subscriber will sell the fruit coming to maturity this season at Perry Hall, twelve miles from the city of Baltimore on three thousand Apple, & nine hundred Peach trees, together with the use of the following conveniences, viz- a DISTILLERY, with two stills, an excellent Screw Cider Press, at which twelve hogsheads of cider per day have been made, a tenement to live in, stable and room for storage of liquor. The trees have, at the least, as much fruit on them as will keep one team steadily employed in collecting, grinding- and taking it to market. There are few places probably in the United States where more or better fruit is collected that an Perry Hall, the late Mr. Gough having, for many years been at considerable expence and uncommon pains to encrease and improve it, persons wishing to examine the trees &c. will apply to Mr. Dimmitt, the manager, on the place.

JAMES CARROLL.

June 16. 3taw 6w

This newspaper advertisement was placed by James Maccubin Carroll in the July 11, 1808, edition of the *North American*. Just two months prior to this, his father-in-law Harry Dorsey Gough passed away. The advertisement, offering crops of apples and peaches for sale, noted that the high quality of the fruit is due to the efforts of "the late Mr. Gough." (Historic Perry Hall Mansion Collection.)

Inventory of the Goods, Chattles, and Personal Estate of the late Harry Dorsey Gough taken at Perry Hall and Sundry Articles there to belonging taken by Thomas Lee & Philip Rogers

In the Drawing Room

12 Mahogany Chairs damask bottom	$ 60
1 Settee Do	40
1 Small Mahogany Stand	2
2 Pier tables Mahogany @ 4 $	8
1 Tea table Do	10
3 prints	18
1 Looking Glass	30
2 Sconces @ $6	12
1 Marble stand	5
1 Fender	16
1 Pair And Irons	5
1 Painted Floor Cloth 4 Gilt Picture frames	16 16

In the Hall

1 Large Settee	16	
1 Doz Arm Windsor Chairs	9	
1 Mahogany Table	5	
1 Glass Lamp	2	
1 New Oyl Cloth not used Say floor Cloth	40	
2 Hearth Rugs	9	50

Carried forward $

In December 1808, after the death of Harry Dorsey Gough in May of that year, Thomas Lee and Philip Rogers completed an inventory of Gough's personal property and goods at Perry Hall Mansion. Room-by-room, they made note of every item. This account, the first page of which is shown here, provides the best description of the general layout of the house and the uses made for each room. The inventory noted the following rooms in the mansion and associated outbuildings: "Drawing Room, Hall, Dining Room, Music Room, Office, Chapel, Best Lodging Room, Portico Chamber, Mrs. Gough's Room, Bedroom, Preacher's Room, Garret, Miss Anna's Room, Miss Hannah's Room, Molly's Room and Pantry, Cellar, Kitchen, Paint Shop, Room by Stephen's Shop, Stable, Wash House, Cooper's Shop, Garden, Quarter, Overseer's House, and Blacksmith's Shop." (Maryland Historical Society.)

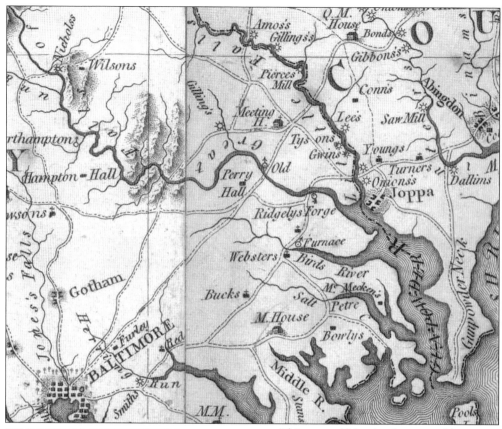

This map of Maryland, prepared by Dennis Griffith in 1794, was laid down from a survey of the principal waters, public roads, and divisions of the state's counties. Given that it notes Perry Hall, it is not surprising that the inventory of Harry Dorsey Gough's possessions conducted after his death references that an engraving of this map hung in the study at Perry Hall Mansion. (Library of Congress.)

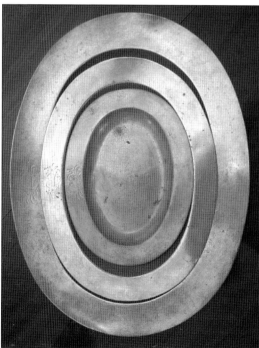

Kitchen items were also referenced in the Gough estate inventory. These three pewter serving platters, which feature the Gough coat of arms at the top center of each piece, were purchased by Harry Dorsey and Prudence Gough and used at the Perry Hall Mansion. Additional platters are also held in the collection of the Mount Clare Museum House. (Private collection.)

A story passed down through generations of Goughs states that this late-17th-century rocking chair was made by slaves at Perry Hall Mansion for use by Prudence Gough when she was pregnant with Sophia. Based upon its appearance, the piece is a "nursing chair." (Private collection.)

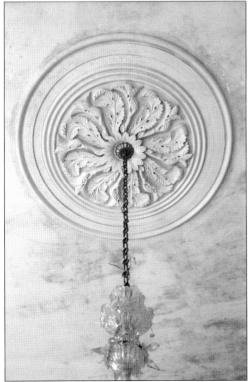

As seen here and as referenced in documents completed for the National Register of Historic Places, a number of plaster ceiling decorations, originally made by John Rawlins in the early 1780s, grace Perry Hall Mansion. Rawlins would later go on to design and install the plasterwork in the banquet hall of Pres. George Washington's Mount Vernon estate, after having been recommended to Washington by Harry Dorsey Gough. (Sean Kief.)

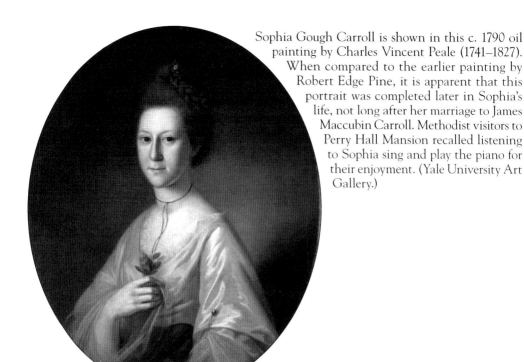

Sophia Gough Carroll is shown in this c. 1790 oil painting by Charles Vincent Peale (1741–1827). When compared to the earlier painting by Robert Edge Pine, it is apparent that this portrait was completed later in Sophia's life, not long after her marriage to James Maccubin Carroll. Methodist visitors to Perry Hall Mansion recalled listening to Sophia sing and play the piano for their enjoyment. (Yale University Art Gallery.)

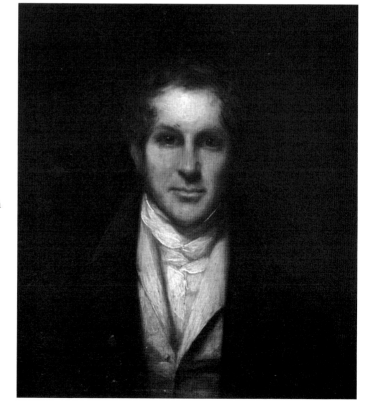

This c. 1832 oil on panel by William James Hubard (1807–1862) depicts Harry Dorsey Gough Carroll (1793–1866), son of Sophia and James Carroll. On January 19, 1815, he married Eliza Ridgely (1797–1828), daughter of Gov. Charles Ridgely and Priscilla Dorsey Ridgely. He would eventually inherit Perry Hall Mansion and supervise its reconstruction after a devastating 1839 fire. (Mount Clare Museum House.)

This c. 1835 silver waste bowl by noted Baltimore silversmith Samuel Kirk features the initials of Harry Dorsey Gough Carroll. Waste bowls were used for collecting unwanted scraps and pieces of food in order to clear the plate. These small circular bowls were also necessary for the serving of tea. Such bowls were used for pouring out the remaining cold tea in a cup before pouring another. (Mark Letzer.)

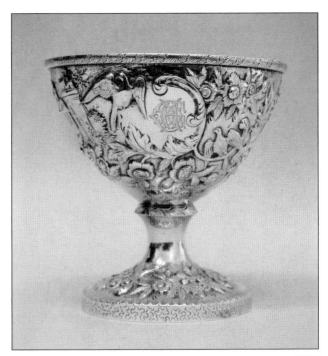

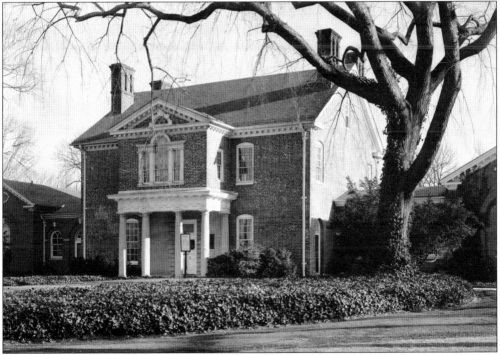

This image shows Mount Clare, the oldest remaining Colonial building in Baltimore. James Maccubbin Carroll, the second owner of Mount Clare, was the father of Harry Dorsey Gough Carroll. It was built in 1760 by Charles Carroll, a barrister and a distant relative of Charles Carroll of Carrollton, a signer of the Declaration of Independence. (Library of Congress Historic American Buildings Survey, photograph by Lanny Miyamoto.)

124

Cost of Rebuilding Perry Hall dwelling

1840 Nov 27	p J. Mathews for 2530 ft Nails		43.25
" "	Carolina Ceiling for floors @ 27		
" "	1050 Prime ceiling white pine @ 19¼		10.37
1841 " "	203 lb french yellow Ocre @ 5¼		15.56
Jan 4	p Tho Mathews		76.45
Feb 5	p A. R. Blakeney for work in Jan.		46.43
Mar 1	p Do Do in Feb.		107.75
Apr 3	p Do Do in March		90.77
" 17	p Bloomer for work on flooring & cellar windows & doors & Delmar		136.00
May	p A. R. Blakeney for work in April		37.43¼
" "	p for furniture for Workmen		20.75
"	p for 3 cellar Locks		5.25
June 7	p A. R. Blakeney for Work in may		29.07½
" 12	" Thomas Mathews for lumber		551.17
" 17	" Patrick Mooney		60.10
July 2	" A. R. Blakeney for Work in June		64.37½
" "	" Patrick Mooney		60.
" 3	" Tenders to Masons to this day		113.61
" 20	" Do Do Do		13.60
Aug 11	" A. R. Blakeney for Work in July		74.01
" 14	" Patrick Mooney in fall		66.05
" 20	105 lb Iron for Lightning rods & hinges		9.07¾
Sep 1	p John Treburge Jr for tin roof		300.37¼
" 2	p A. R. Blakeney for work in August		64.37¼
" "	" for 30 Bus Lime @ 20 cts		6.
" 16	" P Mooney for plastering cellar		17.
Oct 1	" Willson & Lutz for painting &c		120.
" 5	" A. R. Blakeney for work in Sept		75.07
" 30	" A. R. Blakeney for work in Oct		79.10
			$2403.20

According to an account in the *Baltimore Sun*, on December 13, 1839, Perry Hall Mansion "caught fire and was consumed, with a considerable portion of its contents." Harry Dorsey Gough Carroll chose to rebuild almost immediately and kept this detailed record within his ledger, listing all expenses associated with this effort. This process began in March 1840 and was virtually completed by the end of 1844. He began by adding a second story to the surviving west wing; this phase was substantially complete by January 1841 at a cost of $2,961.58. The first charges associated with work on the main portion of Perry Hall Mansion were recorded during late November of 1840. Purchases included marble window sills, lumber, new windows and doors, assorted nails, screws and hinges, servants' bells, and painting supplies. Harry Dorsey Gough Carroll also paid the wages associated with various craftspeople, with overall work being supervised by Baltimore carpenter A.R. Blakeney. Costs for restoration of the main house totaled $2,626.80. (Maryland Historical Society.)

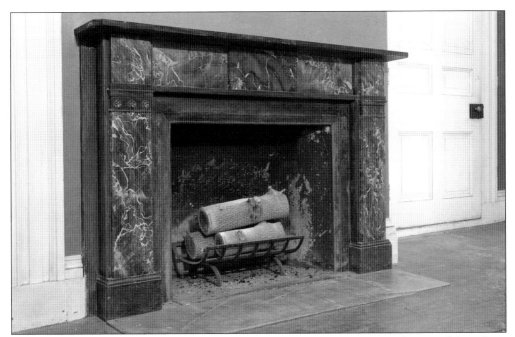

A number of the design features present in today's Perry Hall Mansion can be traced directly to the series of restoration projects conducted under the auspices of Harry Dorsey Gough Carroll. For instance, this and one other Egyptian marble mantle were purchased from Bell and Packie, stonecutters, for placement in the front parlor and the music room. These mantles cost $120. (Sean Kief.)

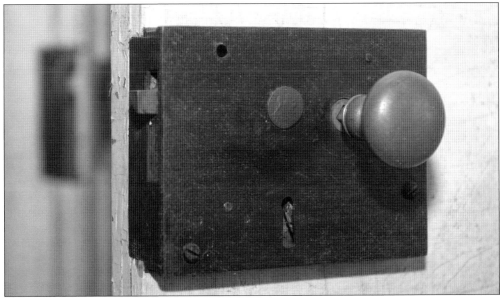

Gough Carroll chose to begin rebuilding by raising the roof on the surviving west wing and adding a second story. He purchased a quantity of wrought iron rim-style locks, manufactured and signed "Carpenter & Company," which were made in England exclusively for export. This type of hardware was widely used in America and the English colonies from about 1820 until the early 1900s. (Sean Kief.)

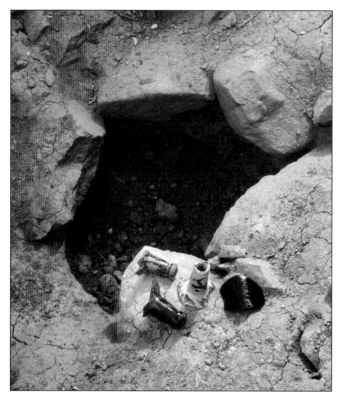

Evidence of Harry Dorsey Gough's earlier days as a freewheeling socialite can still be seen within the house. At one time, a portion of his basement served as a wine cellar. Family lore references a well in a sub-cellar, used for cooling wines and melons. A structure consistent with this description, and containing remnants from period glass wine bottles, is located in the northeast corner of the cellar. (Sean Kief.)

This historic marker was placed at today's intersection of Bel Air Road and Honeygo Boulevard, in close proximity to Perry Hall Mansion. The marker erroneously references 1824 as the year of the fire. This mistake is likely due to cursory review of Harry Dorsey Gough Carroll's ledger, which did reference a quantity of building materials purchased in that year, but not for fire restoration, merely for general improvements. (Sean Kief.)

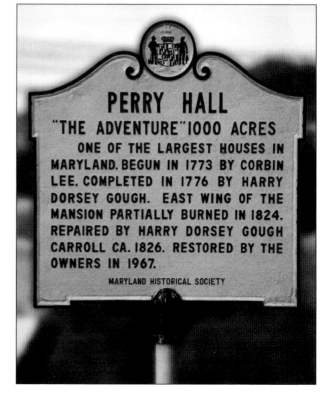

Two

PERRY HALL MANSION IN THE VICTORIAN AGE

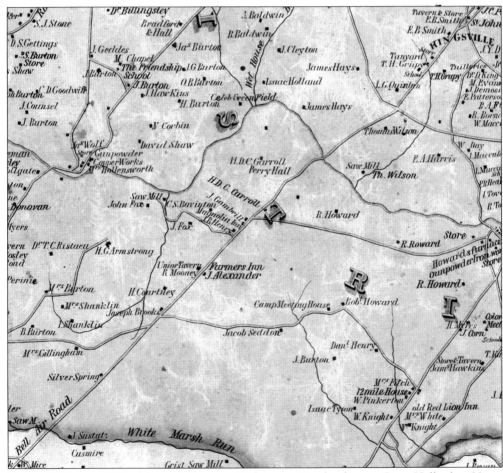

This c. 1850 map of "The City and County of Baltimore, Maryland" notes Perry Hall, when Harry Dorsey Gough Carroll was owner. Not long after this map was released, Gough Carroll sold the house and 894 acres to William Meredith of Philadelphia, Pennsylvania. This was the beginning of a process that occurred over many years, whereby land associated with Perry Hall was sold off into smaller parcels. (Library of Congress.)

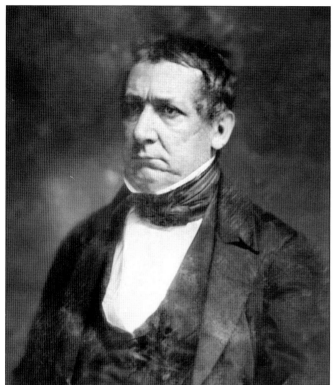

William Morris Meredith (June 8, 1799–August 17, 1873) was an American lawyer and politician. Meredith purchased Perry Hall Mansion on May 15, 1852, for the sum of $22,000. He would later sell a half share in the estate to fellow Pennsylvanian Eli Slifer. Meredith owned Perry Hall Mansion until his death in 1873, after which the house was inherited by his children. (Library of Congress.)

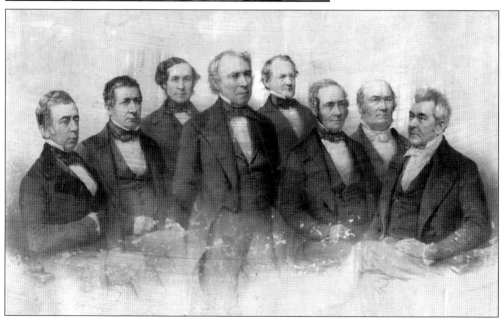

Shortly after his election in 1848, Pres. Zachary Taylor, wanting a Pennsylvania Whig for his cabinet, appointed William Meredith to be the 19th secretary of the treasury. Prior to this, Meredith had served as president of the Philadelphia City Council since 1839. This image shows President Taylor (standing fourth from the left) with Meredith (sitting second from the left). (Library of Congress.)

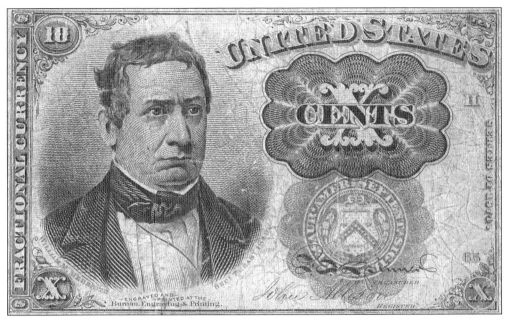

After President Taylor's untimely death in July 1850, Meredith—along with the other members of Taylor's cabinet—resigned his post. Later in his life (1861–1867), Meredith served as the attorney general for the Commonwealth of Pennsylvania. Owing to his former position as secretary of the treasury, Meredith's portrait was featured on this 10¢ US fractional currency printed in 1874. (Sean Kief.)

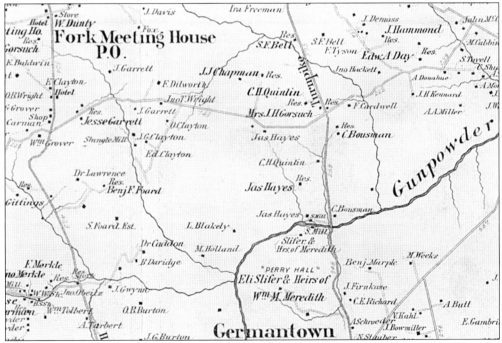

This c. 1877 map of Baltimore County prepared by C.M. Hopkins identifies Perry Hall as the property of "Eli Slifer and heirs of William Meredith." It appears that neither of these men actually lived there at any time. In the upper left, William Dunty Sr., was the owner of a store and the postmaster of Fork, Maryland. In 1888, Dunty would purchase the mansion. (Sean Kief.)

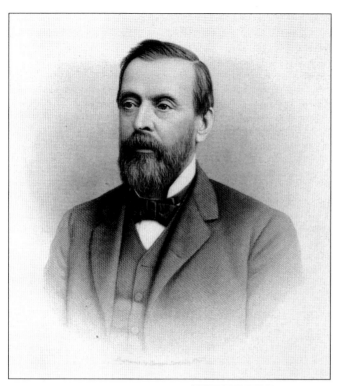

Eli Slifer (May 23, 1818–May 28, 1888) was a prominent Pennsylvania politician, serving in both chambers of the state legislature and as state treasurer. In 1866, William Meredith sold a half interest in Perry Hall Mansion to Slifer for $11,000. Meredith knew Slifer, as Slifer served as secretary of the commonwealth for the same years that Meredith was the state attorney general. (Commonwealth of Pennsylvania.)

After assuming office in 1861, Republican governor Andrew Curtin made Slifer the secretary of the commonwealth, a position he held until 1867. In this office, second only to the governor, Slifer raised and deployed troops and supplies from Pennsylvania for the Union Army during the Civil War. Eli Slifer informed then President-elect Abraham Lincoln of the appointment in this December 1860 letter. (Library of Congress.)

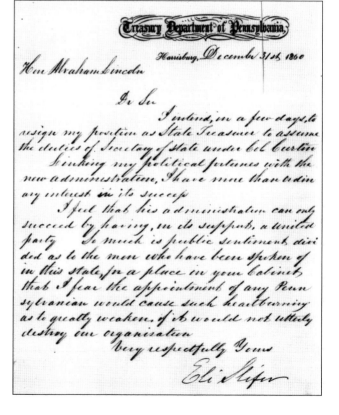

This US Census Bureau record, compiled in August 1870, shows that Samuel Slifer, son of Eli Slifer, resided at Perry Hall Mansion with his wife, three children, and three others. This document is an ideal reference point to show how several families ultimately became connected with the Victorian-era history of Perry Hall Mansion. For instance, it indicates that the family of James Ransom, brother-in-law to Samuel Harley Slifer, resided just two homes away. The family of William Dunty Sr. lived another two houses down from the Ransoms at that time. Later, in 1888, William Dunty would purchase Perry Hall Mansion from Eli Slifer and the heirs of William Meredith. Dunty's son, William Dunty Jr., would also marry James Ransom's daughter Hannah Elizabeth, and they would come to own Perry Hall Mansion in 1894. (US Census Bureau.)

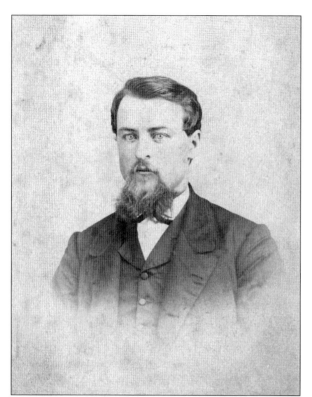

Samuel Harley Slifer (1842–1895) was born in Northumberland County, Pennsylvania. His parents were Eli and Catherine Motter Frick Slifer. He would marry Margaretta Harland Ransom on December 12, 1865. Documents held at Camp Chapel United Methodist Church indicate that Sam Slifer was chosen to serve as secretary on the church board of trustees on February 13, 1869. (Carlene Wilson Silhanek.)

Margaretta "Maggie" Harland Ransom Slifer (1845–1897) was born in Plymouth, Pennsylvania, and was one of 11 children. Maggie and Sam Slifer were the parents of four children: Catherine, Eli Jr., Mabel, and Andrew. Maggie's mother, Mabel Cortright Ransom, ultimately came to live at Perry Hall Mansion, where her daughter cared for her in old age. (Carlene Wilson Silhanek.)

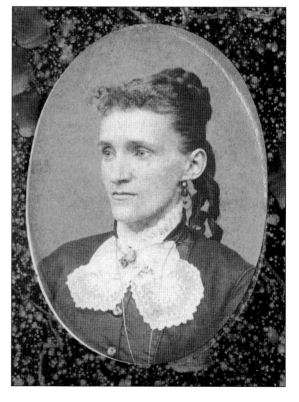

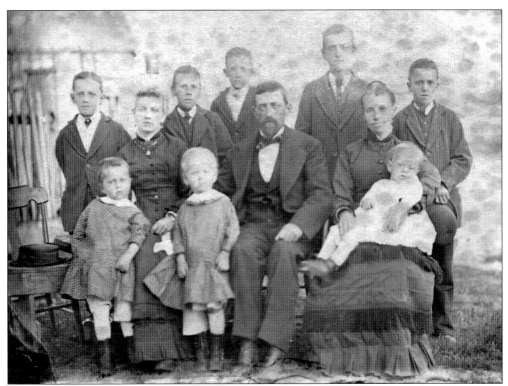

This photograph shows the family of Jameson Ransom (1842–1917), brother-in-law to Sam Slifer. Jameson was Maggie's older brother and came to work at the Perry Hall estate as an adult. He and his wife, Mary Elizabeth Winchester Ransom, were the parents of 11 children. The couple's oldest daughter, Hannah Elizabeth, would eventually marry into the Dunty family. (Greg Conner.)

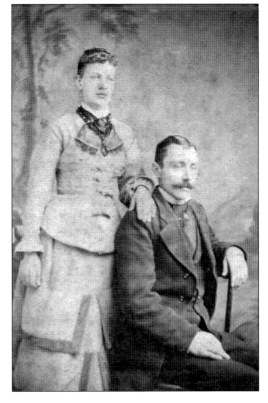

William Dunty Jr. and Hannah Elizabeth "Lizzie" Ransom were married on January 23, 1880. The marriage record notes that he worked as a tinsmith. Census records from 1870 indicate that both individuals lived a few homes apart. Hannah remained with the Dunty family after her marriage, as her father Jameson Ransom and his family moved west when he began working as an Indian agent. (Marion Porter.)

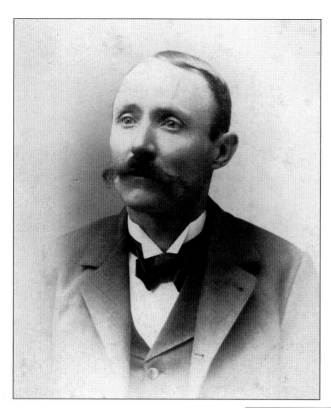

William Dunty Jr. (1855–1929) was the first of two sons born to William Dunty Sr. and Rachel Elizabeth Robertson. Dunty Jr. operated a gristmill and sawmill on the Gunpowder River. He also managed a rock crushing operation at the old Ashland Iron Works, with the stone used to pave Baltimore County roads. Dunty Jr. was an active Democrat, having represented his election district on the state Democratic committee. (Marion Porter.)

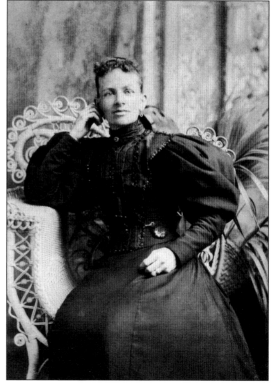

Hannah Elizabeth Dunty (1862–1952) was the daughter of Jameson and Mary Ransom. After her parents relocated to Iowa, Hannah would occasionally travel to visit her family there. Family members recall that she loved to crotchet, with many of her works still held by family members. Great-grandson Stanley Smith remembers that, "she would visit periodically and, as I recall, there was always an air of something special happening." (Marion Porter.)

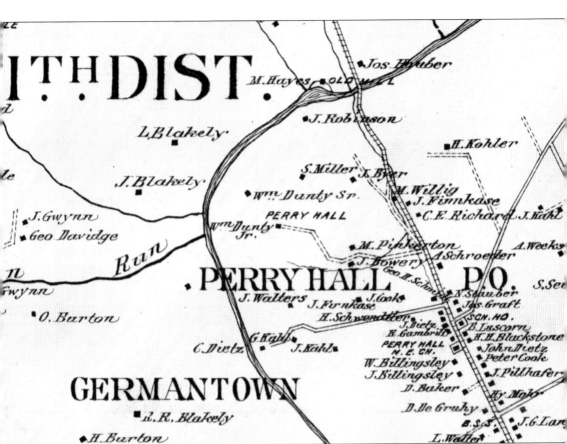

William Dunty Sr. purchased Perry Hall Mansion and 335 acres of land on June 18, 1888, for $8,000. He would eventually provide land for his two sons, William Jr. and John, and also for stepson Jacob Robertson. Prior to his move to the mansion, Dunty Sr. resigned his position as postmaster of Fork, Maryland. Along with farming, Dunty Sr. earned income by selling local properties, then holding a mortgage with the new owner. This c. 1898 map of Baltimore County clearly indicates the 1894 transition of ownership at Perry Hall Mansion from father to son. It indicates that William Dunty Jr. then occupied the mansion, with his father William Sr. residing in a home nearby. To the north of the estate, Jacob Robinson, half-brother to Dunty Jr., also owned property. Over time, the Dunty clan continued to live in close proximity. (Sean Kief.)

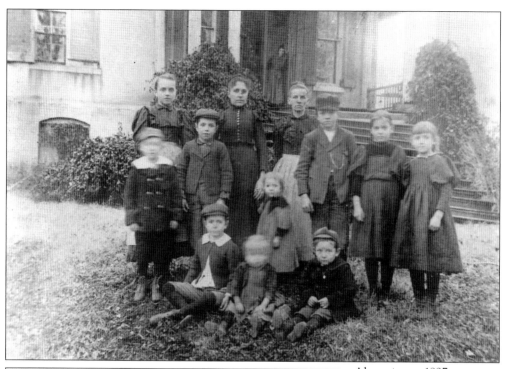

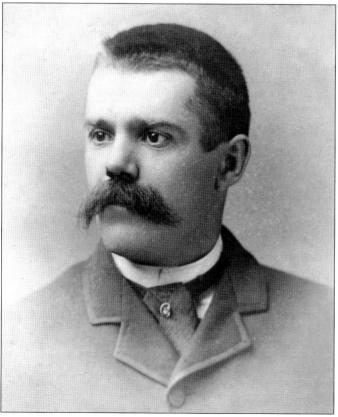

Above is a c. 1897 photograph showing the families of William Dunty Jr. and his younger brother John (1857–1895) standing in front of Perry Hall Mansion. From left to right are (first row, seated) John Ardin (son of John), Bessie, and William George; (second row) James Harvey, Harry Andrew (son of John), Jessie (daughter of John), Robert Perry, Florence, and Edith Ray; (third row) Mary Elizabeth, Alice Carrick Dunty (wife to John), and Hannah Elizabeth. John Dunty, left, died in 1895 at the age of 38 and was buried in the Kingsville cemetery. His widow, Alice Dunty, subsequently moved into Perry Hall Mansion with their three children. (Sean Kief and Jessie Dunty.)

This c. 1894 photograph is the oldest known image showing the inside of Perry Hall Mansion. It appears that it was most likely taken in the front parlor of the mansion facing south, so as to take advantage of sunlight from outside. Shown are the children of John Dunty: John Ardin, Jessie May, and Harry Andrew. (Jessie Dunty.)

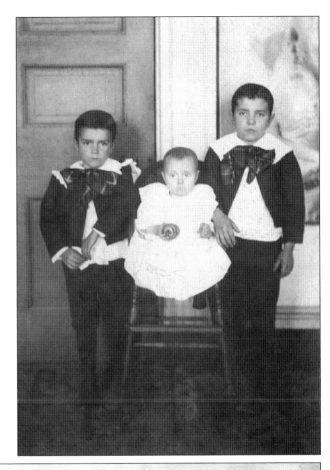

This June 1900 newspaper headline reports that gold was found on the land of William Dunty Jr. Someone claiming to be from the Smithsonian Institution enlisted young Harry Dunty to lead him to the gold. Subsequently the boy mysteriously disappeared, returning safely that night. As a protective uncle, Dunty Jr. indicated that, "if he could meet the man he would save the police the trouble of arresting him." (Sean Kief.)

RAN OFF WITH THE BOY

Supposed Case Of Kidnapping At Perry Hall.

THE NEIGHBORHOOD EXCITED

The Disappearance Of 10-Year-Old Harry Dunty Follows Alleged Discovery Of Gold In The County.

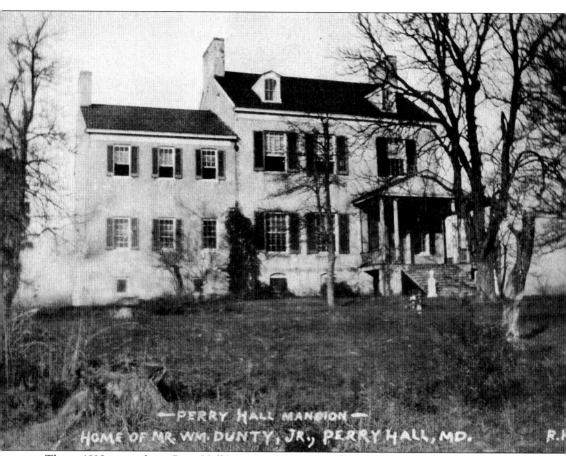

This c. 1890 image shows Perry Hall Mansion as it appeared from the 1850s well into the beginning of the 20th century. When compared to the earlier oil paintings of the mansion, the destruction from the fire of 1839 is quite evident. Using the central portico as a reference point, the observer can clearly note the loss of the entire east wing of the mansion (originally to the right of the front entrance), as well as the adjacent portion of the main house. The addition of a second level to the surviving west wing, one major feature added during the restoration of the mansion after the fire, can be seen to the far left from the front entrance. After being sold by Harry Dorsey Gough Carroll, the house changed hands a number of times and was often owned by absentee landlords. Not until purchase by the Dunty family in 1888 did Perry Hall Mansion once again enter a period of stable residency. (Sean Kief.)

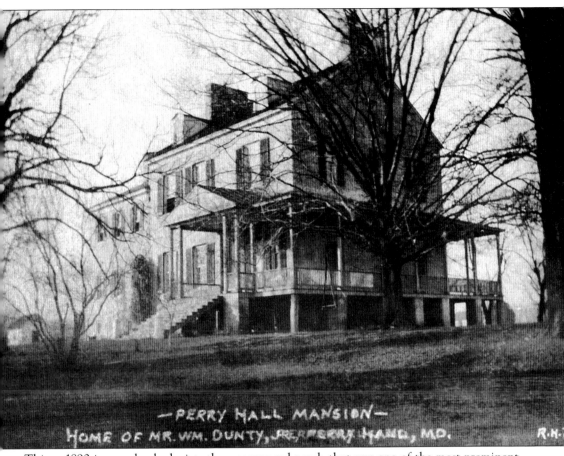

—PERRY HALL MANSION—
HOME OF MR. WM. DUNTY, JR., PERRY HALL, MD. R·H·

This c. 1890 image clearly depicts the wraparound porch that was one of the most prominent features added to the house as a consequence of the 1840s renovation project. During the latter half of the 1800s, the area surrounding the Perry Hall Mansion experienced a dramatic change. Former mansion lands and other adjacent large properties were subdivided into smaller farmsteads. These new farms were most typically owned by recent immigrants from Germany. A number of these newcomers, including the Butt, Dietz, Huber, Kahl, Klausmeier, and Rye families, would ultimately become some of Perry Hall's most prominent residents. Given the influx of families from central Europe, it is not surprising that the community was referred to as Germantown during the latter half of the 19th century. This name would persist until the opening of a new post office for the area near the end of the century. (Sean Kief.)

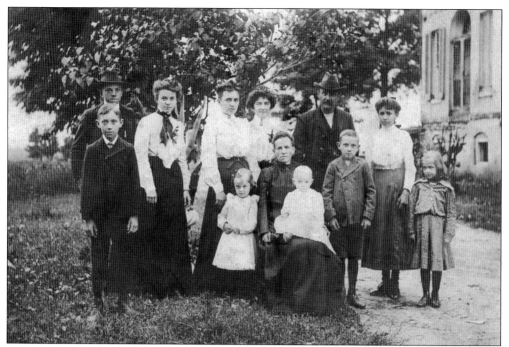

This c. 1903 photograph shows the family of William Dunty Jr. on the north lawn to the rear of the mansion. From left to right are (first row) James Harvey, Hazel Winifred, Hannah Elizabeth, Osborn Yellot, and William George; (second row) Robert Perry, Florence May, Mary Elizabeth, nursemaid Susan Clayton, William Dunty Jr., Edith Ray, and Bessie Viola. (Marion Porter.)

BIRTHS.			
CHILDREN OF *William and Lizzie Dunty*			
GIVEN NAME.	DATE.	PLACE.	STATE.
M. E. Dunty	April 3, 1881	Anne Arundel Co.	Md.
H. H. Dunty	Feb 16, 1883	Perry Hall Balto Co	Md.
R. P. Dunty	April 28, 1885	Perry Hall Balto Co	Md.
F. M. Dunty	April 3 1887	Perry Hall Balt Co	Md.
E. R. Dunty	Feb 1 1889	Perry Hall Balto Co	Md.
J. H. Dunty	June 29 1891	Perry Hall Balto Co	Md.
W. G. Dunty	April 22 1893	Perry Hall Balt Co	Md.
B. V. Dunty	May 25 1895	Perry Hall Balto Co	Md.
Hazel Dunty	June 4 1899	Perry Hall Balto Co	Md.
Osborn Dunty	March 3. 1902	Perry Hall Balto Co	Md.

FAMILY RECORD.

Lizzie Ransom Dunty was a descendant of Revolutionary War captain Samuel Ransom, slain at the Massacre of Wyoming, Pennsylvania. Cpt. Clinton Sears documented the Ransom line and published his work in an 1882 book. The pages, shown here, were used by family members to document the family line. Here, Lizzie listed each of her children with Dunty Jr., nine of whom were born at Perry Hall Mansion. (Casey Phillips.)

In 1878, the family of Harry Dorsey Gough Carroll donated an acre of land for use as the site of a new school. Located at the intersection of Bel Air and Forge Roads, this three-room brick schoolhouse was named Baltimore County School No. 8 but was commonly known as the Perry Hall School. This c. 1899 schoolyard photograph includes two Duntys, James Harvey and William George Dunty. (Sean Kief.)

This c. 1897 photograph shows William George Dunty (seated) and his older brother James Harvey Dunty. Many people remember James Harvey as "Babe," a nickname generated by family members who called him Aunt Lizzie's "babe." As an adult, he would operate a barbershop and eventually become the postmaster of Perry Hall on September 9, 1933. (Sean Kief.)

47

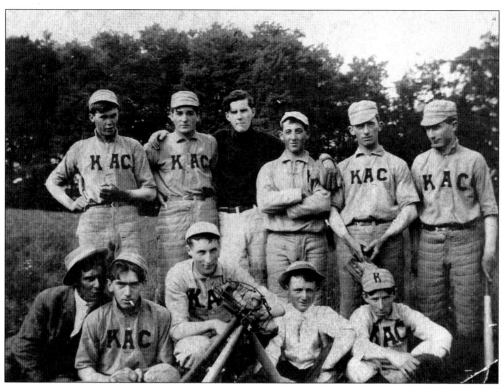

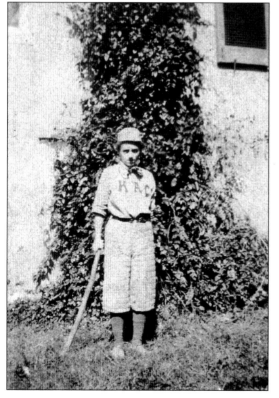

Robert Dunty was the oldest son of William Jr. and Elizabeth Dunty. He was an avid baseball player. Many newspaper accounts can be found between 1906 and 1908 that list him as the centerfielder for the Kingsville Athletic Club. Perry Hall and surrounding communities shared America's growing love of baseball. (Casey Phillips.)

The relative popularity of baseball within the Dunty family was shared by the girls as well. In this image, Mary Dunty is seen standing in front of Perry Hall Mansion wearing the uniform of the Kingsville Athletic Club. The playing fields used by this team were just a couple of miles to the north of the mansion. (Marion Porter.)

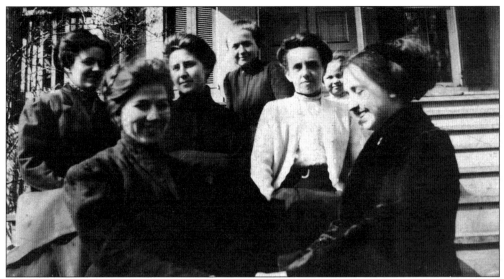

The Dunty women took special pleasure in entertaining guests. A September 13, 1908, newspaper article, "Misses Dunty Entertain," tells of a party planned by Florence, Mary, and Edith Dunty and held in honor of their friends Norma and Ethel Thelme. Games, singing, and dancing were the featured activities for that evening of fun at Perry Hall Mansion. From left to right are (first row) unidentified and Edith Dunty; (second row) Floss Dunty, Mamie Miller, and Mary Dunty; (third row) Bessie Dunty and Mildred Williams. (Casey Phillips.)

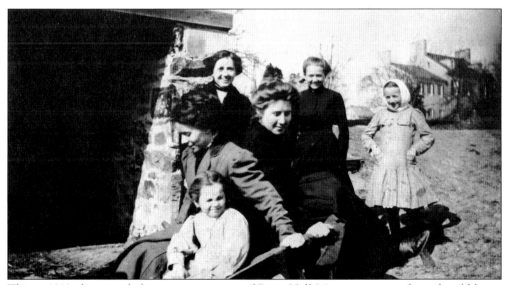

This c. 1910 photograph features a rare view of Perry Hall Mansion as seen from the old barn. The foundation of this structure can be seen to the left center. The young women at play are, from left to right, (first row) Mildred Williams; (second row) Floss Dunty and Mamie Miller; (third row) Edith, Bessie, and Hazel Dunty. (Casey Phillips.)

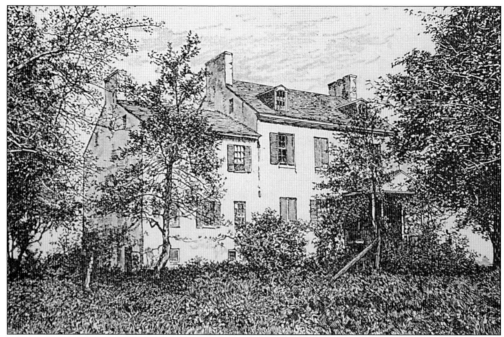

In late 1899, Bishop John F. Hurst wrote *The History of Methodism*, a book issued by New York Publishers. His work made reference to the important role that Perry Hall Mansion in general, and Harry and Prudence Gough in particular, played in the formative years of the Methodist Church in the United States. Hurst retold the story of the close relationship between the Goughs and church founders Bishops Asbury and Coke. These images were included within Bishop Hurst's narrative; they depict the mansion and an outbuilding referred to as the "slave jail." (Lovely Lane Church Museum and Archives.)

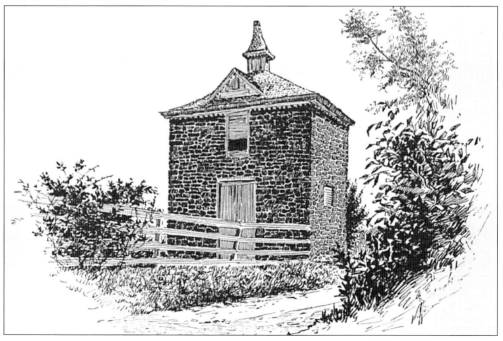

This c. 1897 photograph shows a structure that existed at the Perry Hall estate until sometime around 1913. Local legend has it that this was actually a slave jail, used during the time of Harry Dorsey and Prudence Gough. According to accounts from the time of the Duntys, this building had a large hook that hung in the center of the structure, and underneath was a shallow depression, covered in sheet metal, identified as an "escape proof pit." This description sounds suspiciously like a smokehouse, but it is conceivable that the Goughs had occasion to use the structure as lore suggests. Some evidence does exist to at least lend some credence to the idea of the structure being used for other purposes, as shall be seen later in this account. (Photograph by George Fox.)

These c. 1910 images show Mary Dunty. At left, she is standing on the west lawn of the mansion. Mary, wife to Charles Quinlin after 1912, would live to just shy of her 100th birthday. As seen below, she was fond of horses. Mary Dunty would share stories of how the Dunty children slept as a group during the winter in order to keep warm. (Casey Phillips.)

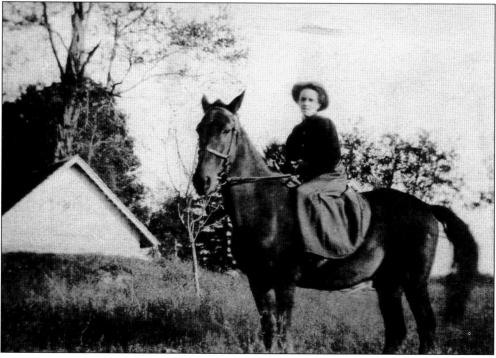

Florence "Floss" May Dunty, shown here, was the fourth child of Elizabeth and William Dunty Jr. She was born at the Perry Hall Mansion on April 3, 1887, and eventually married David A. Smith. As a grandparent, Floss Dunty Smith told her grandchildren of loving her time at the mansion, saying that she wished it would have been possible to have spent her entire life at the home. She passed away on December 29, 1977, some 37 years after her husband died. This longevity came in spite of her bout with typhoid fever sometime during 1900. (Casey Phillips.)

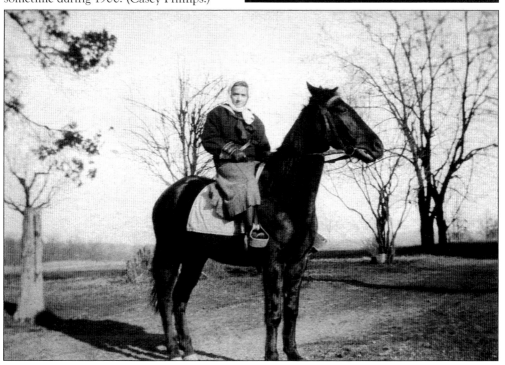

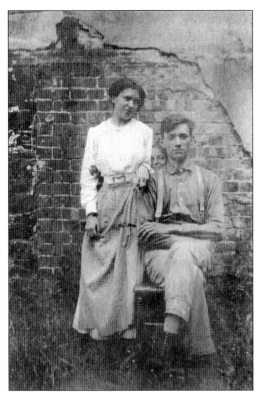

Jessie Dunty poses with her cousins Babe Dunty (left) and Bessie Dunty (below). A keen eye can also spot Osborn "Mike" Dunty peeking over the shoulder of his brother Babe. After leaving the mansion, Babe Dunty would serve during the First World War. Later, in early 1936, a group of 17 World War I veterans from the communities of Overlea and Perry Hall joined together and submitted an application to start an American Legion Post. A temporary charter establishing Overlea Post 130 was issued in December 1936. The first meetings were held in the then Fullerton Post Office on Bel Air Road with James H. (Babe) Dunty, the postmaster, serving as commander. A permanent charter was issued on May 20, 1940, and the post closed its charter membership roll with exactly 50 members. (Jessie Dunty.)

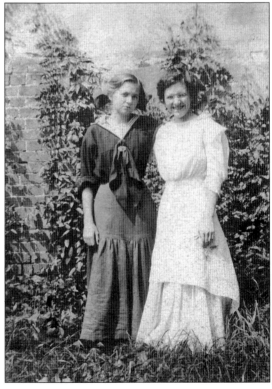

Jessie, the daughter of John Dunty, and her cousin Bessie Dunty, the daughter of William Dunty Jr., are pictured here. Even after a variety of new additions to the family, and shifting living arrangements, the Duntys remained as a close family unit. In subsequent years, family members still typically resided near each other. (Jessie Dunty.)

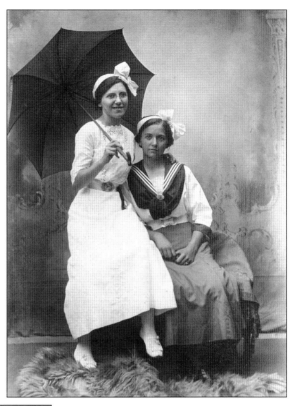

Osborn Yellot Dunty was the youngest child of William Dunty Jr. and Elizabeth Dunty. Osborn was born March 3, 1902, at Perry Hall Mansion. He was named after a prominent lawyer who worked in Towson, Maryland, due to the strong interest that Dunty Jr. had in local politics. Osborn would later adopt the name Mike. (Casey Phillips.)

William George Dunty (pictured) was born in 1893 at Perry Hall Mansion. He was the seventh child of William Jr. and Elizabeth Dunty. William George would often share with his grandson Kenny Smith stories of how he used to keep pigeons on the third floor of the mansion. More serious culinary and literary pursuits were also part of the legacy of William George and the other younger Duntys. There are many newspaper clippings from the *Baltimore Sun* that indicate that his sisters and cousins would submit recipes for contests, even on occasion sending in poems and short stories for publication. When not at play, the children and their parents spent time practicing their faith. The Duntys were staunch Methodists who over the years attended Fork United Methodist and Saint John's Methodist Episcopal Churches. Babe Dunty was buried at the church in Fork, while William Dunty Sr., his first wife Rachel Elizabeth, and John Dunty were all buried at St. John's. (Casey Phillips.)

Mamie Dunty poses for the camera. The increased availability of photographic equipment made it relatively easy for the Dunty family to capture their time at Perry Hall Mansion. As a consequence, the early 20th century is one of the best visually-documented eras of the mansion and its occupants. (Casey Phillips.)

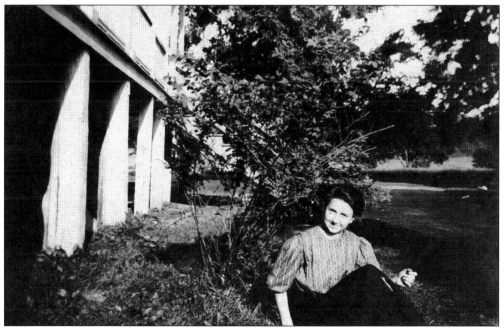

Edith Ray Dunty was born February 1, 1889. Many of the Dunty family members were known for their longevity, with most living well into their 90s. Unfortunately, Edith Dunty died of tuberculosis at the young age of 33. Her passing was hard on her siblings, with many of them choosing to name their children after her in later years. (Casey Phillips.)

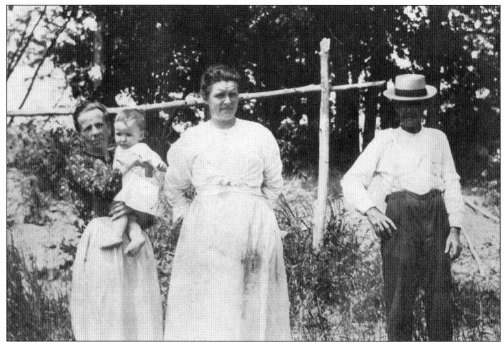

Hannah Elizabeth Dunty holds her grandson Billy Fortune Smith. Her daughter Floss Dunty Smith, standing next to her, is pregnant with a second child. On the far right is Floss Smith's father, William Dunty Jr. The trio of adults is in the midst of enjoying an afternoon outing on the nearby Great Gunpowder Falls. (Casey Phillips.)

This covered bridge existed up until the early 1900s on the nearby Baltimore and Jerusalem Turnpike. Incorporated by the Maryland General Assembly in 1867, the turnpike continued to operate until around 1911. The right-of-way for this road now serves as modern-day Bel Air Road. The current bridge at this location was dedicated to Harry Dorsey Gough in October 2004. (Casey Phillips.)

Members of the Dunty family enjoy a day of recreation on the Great Gunpowder Falls. This sort of swimming and boating was only possible prior to the time when the river was dammed to create Loch Raven Reservoir. This dam was constructed between 1912 and 1914, and when completed, its crest was 188 feet above mean sea level and 51 feet from the original valley floor. A news article from August 18, 1898, described how nearby landowners, including William Dunty Jr., were compensated for losses of property associated with the planned reservoir. Dunty Jr. received $200. (Casey Phillips.)

As one might expect at a country home, animals were often present at Perry Hall Mansion. In the image above, Osborn "Mike" Dunty sits in a wagon with a number of kittens and one of the family's canine companions. The stairs to the porch of the mansion can be seen clearly in the background. Below, William G. Dunty sits along the Great Gunpowder Falls with another one of the Dunty's dogs. William was an avid hunter and was also known as one of the best shots in Perry Hall. His grandson remembers him participating in many turkey shoots and coming home with the prized bird. (Casey Phillips.)

Mary "Mamie" Dunty sent this c. 1910 photograph postcard to her maternal cousin James Ransom, then living in Iowa. Even though they lived many miles apart, members of the extended Dunty/Ransom family remained connected through mailed letters and photographs. It is interesting to note that the postmark on the card indicates that the sending post office was located in Glen Arm, Maryland. While Perry Hall once had a post office, this service was discontinued in 1906. It was not until 1961 that Perry Hall once again had its own post office. (Marion Porter.)

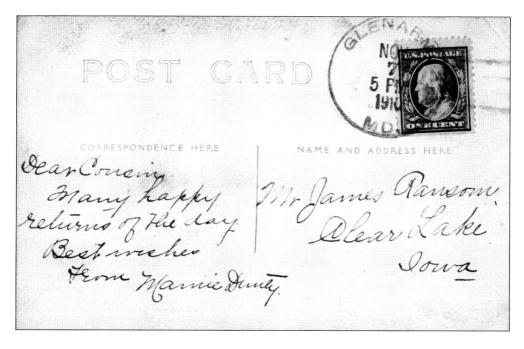

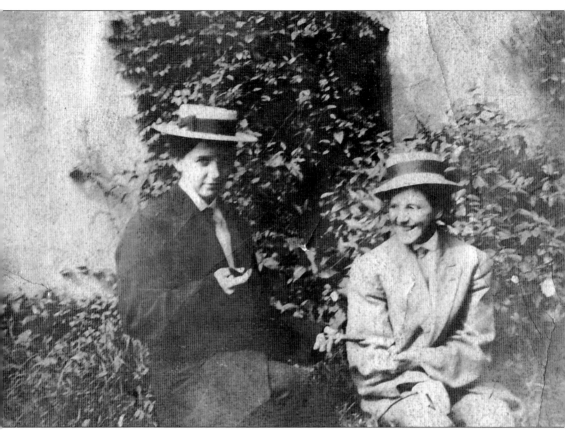

This photograph shows Bessie (left) and Jessie Dunty. Jessie Dunty remembers her times at Perry Hall Mansion quite fondly. Her daughter recalls their mother sharing stories of dressing up like boys ostensibly to elicit the displeasure of their grandfather William Sr. As a proper gentleman of the time, Dunty Sr. did not consider this behavior fitting or proper for young ladies. Given his displeasure, the girls reveled in teasing him, proceeding to run around him in circles while wearing boy's clothes. It would appear that the girls were ahead of their time, as such attire was quite fashionable for women in the 1920s. (Jessie Dunty.)

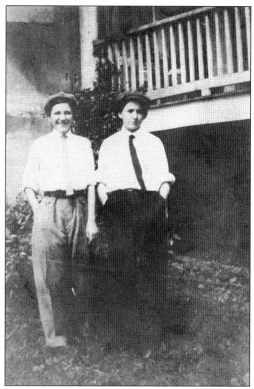

Over the course of her life, Jessie Dunty (at left in both photographs, with Bessie Dunty) would often reminisce of the fun she and her siblings had playing in and around Perry Hall Mansion. Specifically, she spoke of playing a variety of games, including hiding in one of the closets of the great house while playing hide and seek. Jessie Dunty also recalled that visiting members of the extended Dunty family would occasionally bring ballast stones from some of the numerous oceangoing ships that would be docked in the nearby port of Baltimore. Such stones would be reused for the flooring of the cellar at Perry Hall Mansion. (Jessie Dunty.)

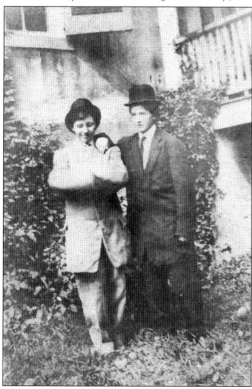

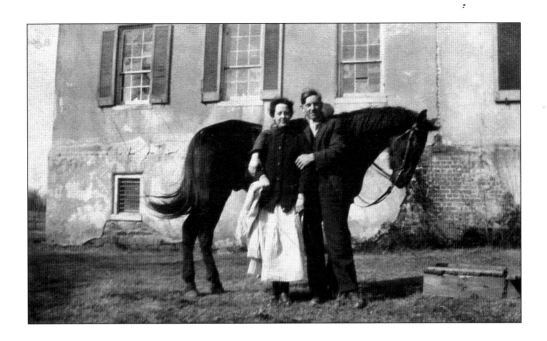

William George Dunty is shown here with his wife, Celeste Lucille Derwart, whom he married January 28, 1914. Celeste was from East Baltimore and took a position working for Joseph Baumiller and family, bringing her to the Perry Hall area. The couple was married for over 40 years, until William's death in 1955, and had four children. Grandchildren still recall them as being two very kind and sweet individuals. Celeste Dunty would often tell her grandchildren the story of neighbor John Miller. He lived close to the mansion and, as a friend of William George Dunty's, would frequently visit in the evening. When Miller left to walk home, he would take "Pop" Dunty's muzzle loading flintlock "for protection." (Sean Kief.)

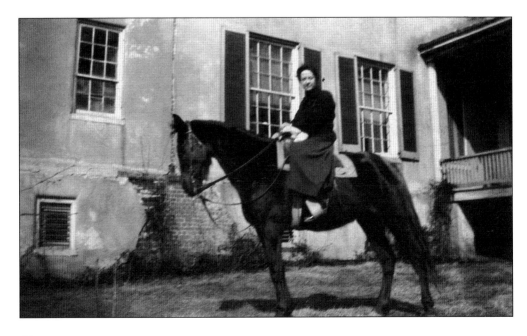

Celeste Dunty gave birth to her first child, Myrl Marie Dunty (shown at right and on the far right in the image below), on February 9, 1915, in the upstairs bedroom of the Perry Hall Mansion. Myrl Smith (née Dunty) would often tell the story of how her grandfather wanted the baby to be born on the second floor so she would always have "High Hopes." As an adult, Myrl worked in the post office with her Uncle Babe, becoming postmaster herself in 1959. She lived in the immediate vicinity of the intersection of Bel Air Road and Joppa Road, where many other family members also resided in later years. (Sean Kief.)

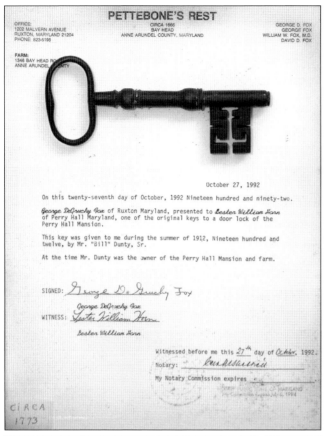

PETTEBONE'S REST

CIRCA 1666
BAY HEAD
ANNE ARUNDEL COUNTY, MARYLAND

OFFICE:
1202 MALVERN AVENUE
RUXTON, MARYLAND 21204
PHONE: 823-5198

GEORGE D. FOX
GEORGE FOX
WILLIAM W. FOX, M.D.
DAVID D. FOX

FARM:
1346 BAY HEAD R...
ANNE ARUNDE... ...NTY

October 27, 1992

On this twenty-seventh day of October, 1992 Nineteen hundred and ninety-two.

George DeGruchy Fox of Ruxton Maryland, presented to *Lester William Horn* of Perry Hall Maryland, one of the original keys to a door lock of the Perry Hall Mansion.

This key was given to me during the summer of 1912, Nineteen hundred and twelve, by Mr. "Bill" Dunty, Sr.

At the time Mr. Dunty was the owner of the Perry Hall Mansion and farm.

SIGNED: *George DeGruchy Fox*

George DeGruchy Fox

WITNESS: *Lester William Horn*

Lester William Horn

Witnessed before me this 27th day of October, 1992.

Notary: *Ben Alshurich*

My Notary Commission expires ...

CIRCA
1773

These artifacts date from the Colonial era at Perry Hall Mansion. The key shown here does conform to the style and relative size that was common in late-18th-century locks. Indeed, a number of the surviving original doors at Perry Hall Mansion possess keyholes large enough to accommodate this key. Also shown here is a set of handcuffs found inside the Gough smokehouse. These handcuffs also have been determined to date from around 1790. George Fox, the gentleman who originally found the handcuffs, presumed that their presence in the mystery structure confirmed its origins as a "slave jail." It is more probable that the structure was in fact a smokehouse that may have occasionally been used for the alternative purpose suggested. (Lester Horn.)

William Dunty Sr.'s first wife passed away in 1893. Subsequently, in 1900, he remarried Annie Elizabeth Donahue. The couple had two children, shown here, John William Dunty and Laura Emma Dunty. Laura was born in the mansion and eventually married Lewis E. Pearce Sr. in 1921. The couple was married for a total of 81 years to the day. (Lewis Pearce.)

On July 13, 1915, after 27 years of Dunty residency, Perry Hall Mansion was sold outside of the family. Individual members of the family remained living within the larger community, which was by now referred to more as Perry Hall, as opposed to its earlier moniker, Germantown. This Baltimore County atlas for 1915 still identifies Perry Hall Mansion as having been under the ownership of the Duntys. (Sean Kief.)

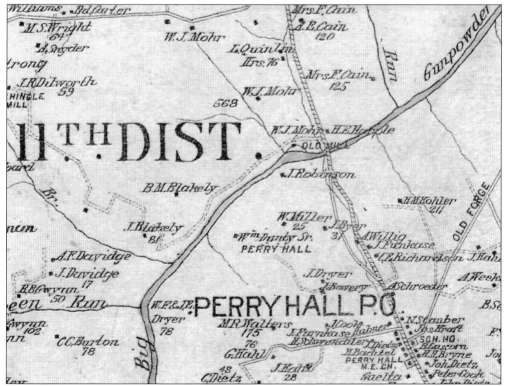

These photographs depict the attic of Perry Hall Mansion over the west wing. At left, two parallel "ghost" lines are present on the exposed brick wall of the main block of the house, as it appears along the attic staircase. These lines indicate the position of the original lower gable roof that covered the west wing prior to the 1839 fire. Harry Dorsey Gough Carroll chose to add a second story to this surviving wing so as to recover some of the living space that was lost as a consequence of the destruction of the old east wing. The photograph below shows similar ghost lines along the roof ridge of the chimney. (Sean Kief.)

This is the underside of the Victorian wraparound porch that encircles the main house. Note the English bond brick used in the original construction of Perry Hall Mansion to the right, while beyond the window, the stucco covering is shown, still tinted with the French yellow ochre that was used for restoration work after the fire of 1839. (Kaestner family.)

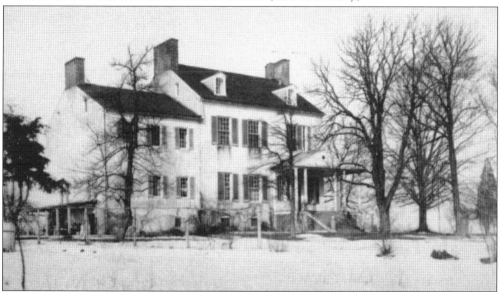

This is a c. 1918 image of winter at Perry Hall Mansion. It was taken during the brief period that Sarah Agnes Watson Coursey, wife of Dr. Charles Coursey, owned the mansion and grounds. The Coursey family only lived in Perry Hall Mansion from 1916 until 1918. After her husband's tragic illness, Sarah transferred ownership of the property to Mercantile Trust Company of Baltimore. (William Fisher.)

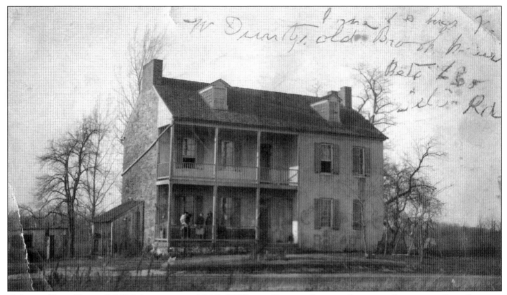

After selling Perry Hall Mansion in 1915, William Dunty Jr. opted to purchase another famous house located in the community, Bishop's Inn (built about 1813). During the late 1800s and early 1900s, the house saw thriving business as a way station for travelers using the Baltimore and Jerusalem Turnpike, today's Bel Air Road. (Sean Kief.)

In 1950, after nearly 40 years away, Hannah Elizabeth Dunty returned to Perry Hall with the family of her son William G. Dunty. The family members are, from left to right, Celeste Dunty, Hannah Elizabeth, Myrl Dunty Smith, William Dunty, Dale Smith (child), Kenny Smith, Mae Dunty, and Anna "Sis" Dunty Getz. (Sean Kief.)

Three

PERRY HALL MANSION IN THE 1920S AND 1930S

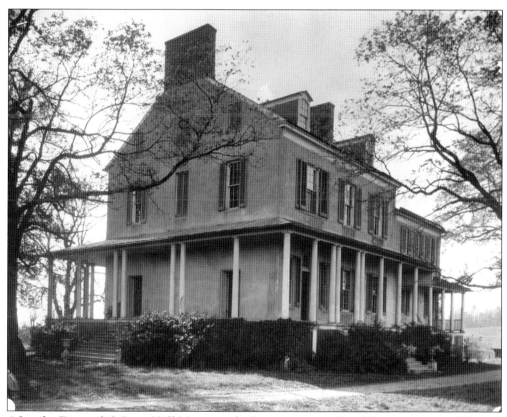

After the Duntys left Perry Hall Mansion, the house was transferred between various absentee landlords. Between 1915 and late 1924, no less than four separate parties owned the mansion: George Buchholz (1915), Sarah Agnes Coursey (1916), Mercantile Trust and Deposit Company of Baltimore (1918), and Harry and Estella Shackleford (1919). This photograph appeared with an October 21, 1921, newspaper article during the time of the Shacklefords' ownership. (*Baltimore Sun.*)

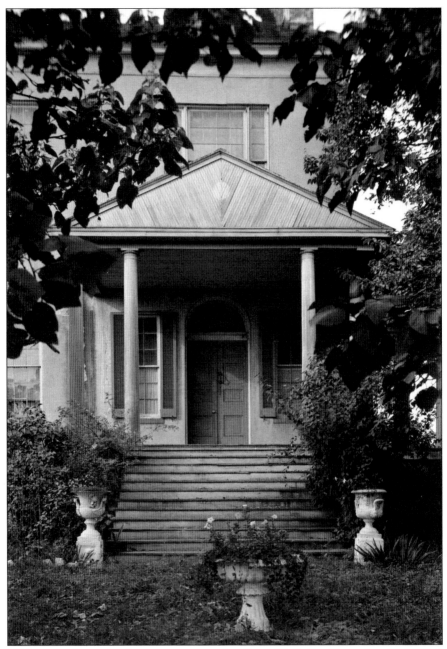

This 1936 image shows the front entrance to the Great Hall. On December 30, 1924, Joseph Plummer purchased Perry Hall Mansion, beginning a period of 24 years of residence by this family. The Plummers purchased Perry Hall after they had sold their family farm located on Park Avenue in Baltimore's Gardenville community. At that time, the family consisted of Margaret Plummer, her sons Joseph and William, and her two daughters Louise and Clara. Joseph Plummer was never to marry, and the property was titled in his name. In 1925, shortly after the purchase of the house, brother William Plummer would marry, and he and his new wife Eva Plummer would raise their family at the mansion. (Library of Congress Historic American Buildings Survey, photograph by E.H. Pickering.)

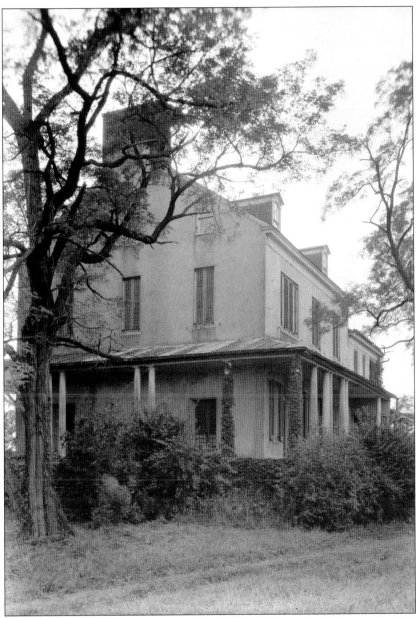

This is the final photograph from E.H. Pickering's visit to Perry Hall Mansion for the Historic American Building Survey; it shows the northwest corner of the back of the mansion in 1936. William and Eva Plummer were the parents of three children: Mary, Sybilla, and Adam. The latter two children were both born in the northeast bedchamber of the main portion of Perry Hall Mansion. Interviews with Sybilla Kramer (née Plummer) indicate that during the colder winter months when she and her siblings were quite young, all of the family members slept in two rooms on the first floor (the front parlor and the music room) in order to conserve heat. As the Plummer children grew older and were less susceptible to winter illnesses, they moved to their own bedrooms on the second floor. Family members have also noted that the house remained cool in the summer in spite of the hot weather, in all likelihood due to the thick masonry walls. (Library of Congress Historic American Buildings Survey, photograph by E.H. Pickering.)

According to Adam Plummer (shown in this 1941 photograph), "there was no electricity on the farm or in the house until November 1940. The family used Aladdin lamps, as they provided a higher level of light when compared to the normal kerosene lamp of that day. I do not recall using this type of light in the bedrooms, as activities were performed in the daylight hours." (Sybilla Kramer.)

The family's access to water also posed challenges. Adam Plummer recalls, "A 1,000 gallon tank was located in the cellar for water supply. Water was pumped with a large Meyer's deep well powered by a single cylinder gasoline engine of the kind you see at steam shows today; not the Briggs and Stratton type as presently used. The well was hand dug, 50 feet deep." (Markus Plummer.)

According to Adam Plummer, the area surrounding the house, considered the lawn, was not maintained in those early years. This was possibly the reason one would find an occasional copperhead snake in the basement of the house. The surrounding farm was well populated with various kinds of snakes, which were encountered often. Also, visits from fox, groundhog, and skunks were frequent. The Plummer children recall that a portion of the property was used for farming operations, particularly during the early 1930s. Wheat and other related crops provided food for the family's livestock, as well as other crops for food and income. Potatoes, turnips, and carrots were the primary crops grown in the 1930s using local seasonal help to harvest them. This photograph shows Sybilla Plummer tending to some of the chickens kept by the family. (Sybilla Kramer.)

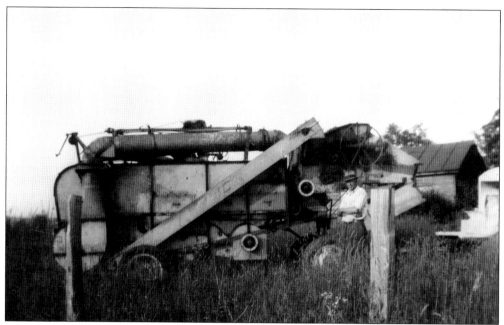

During the tenure of the Plummer family, Perry Hall Mansion was a 204-acre farm that contained a large barn along with other associated buildings. Along with the farm enterprise, William Plummer and his brother Joseph acquired a Frick Steel Threshing machine. The brothers Plummer used this device in order to develop a clientele of farmers throughout eastern Baltimore County and into Harford County. The Plummers performed custom threshing of grain during the 1930s and beyond. Originally, the threshing machine had been mounted on steel wheels. Somewhat later, as seen in these two c. 1942 images, William Plummer was able to convert the thresher to ride on rubber tires. (Markus Plummer.)

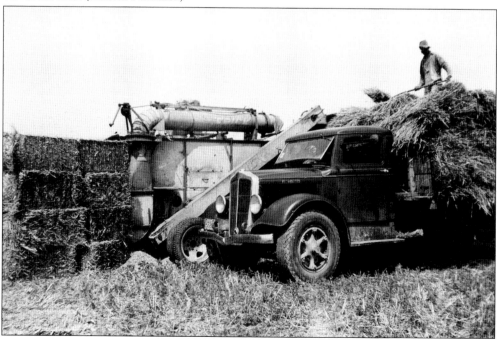

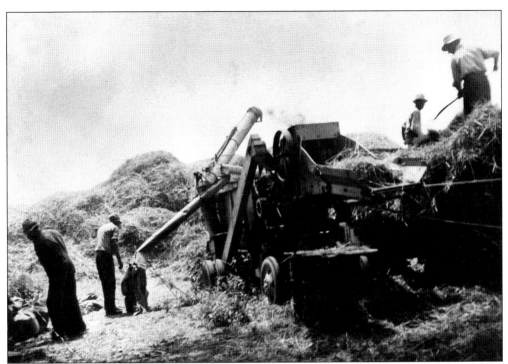

Before the Plummers acquired their own thresher, small grain was threshed on the farm by Ed Simms, another resident of the Perry Hall area. Simms used an old International Harvester gasoline tractor that looked like a steam engine. One would hear it coming as it moved very slowly from the adjoining Dreyer Farm on Perry Hall Road. Crop rotation at the Plummer farm produced turnips and carrots in late fall, which were then buried in earthen kilns. In very late winter, these were removed, washed, and then sent to market. At some point, it was said that the carrots were fed to racehorses. (Markus Plummer.)

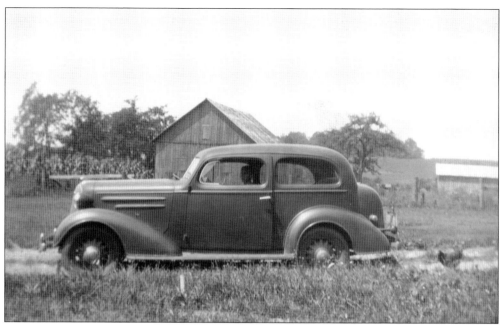

The road leading to Perry Hall Mansion was not paved until the early 1940s. It was just a rough dirt road with fieldstones as a base—muddy in the spring and winter, dry and dusty in the fall and summer. During the 1930s, mail service was not available; one had to go to the post office at the intersection of Bel Air and Joppa Roads. (Sybilla Kramer.)

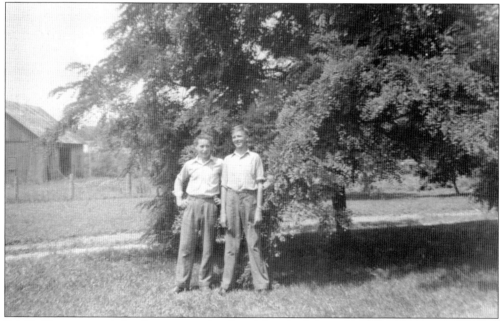

Sybilla Kramer noted that her younger brother Adam (right) would sing at the top of his voice as he went upstairs by himself in order to drown out any scary, creaking noises. Sybilla playfully recalled teasing her younger sibling for being scared when he did this. Here, Adam Plummer is shown with neighborhood friend George Miller, whose family lived adjacent to the mansion grounds. (Sybilla Kramer.)

William and Eva Plummer rarely used the Great Hall during their time at the mansion, except for when Eva would go there to play a few tunes on her piano. None of the family members lived in any of the rooms on the mansion's third floor. Typically, those rooms were only visited twice per year for the purpose of scrubbing the pine flooring. (Sybilla Kramer.)

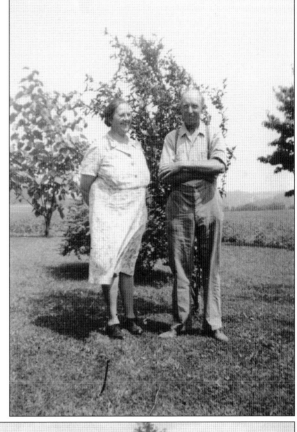

Surviving family members have remarked on the lush landscaping present at Perry Hall Mansion during the 1930s and 1940s. Near the southeast corner of the house was a very large spreading beech tree, seen here. Just south of the house grew two very tall spruce trees; the family always referred to them as pine trees. (Markus Plummer.)

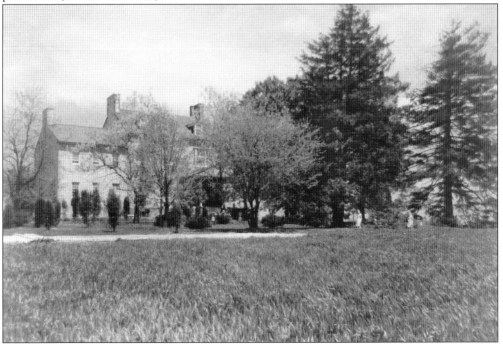

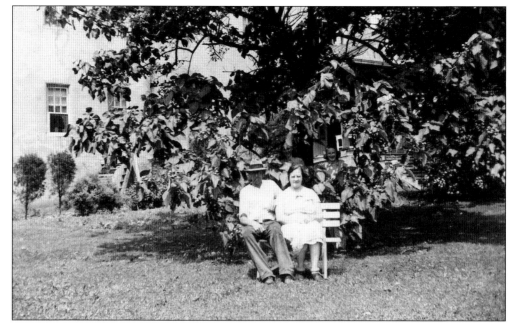

According to her children, Eva Plummer (pictured with her husband in 1941) was glad to leave Perry Hall Mansion, given the challenges associated with living in such a large, old home. As an example, Eva complained that it took a whole bolt of fabric to make one curtain. William Plummer would have to build a scaffold inside the house in order to paint the high walls. (Markus Plummer.)

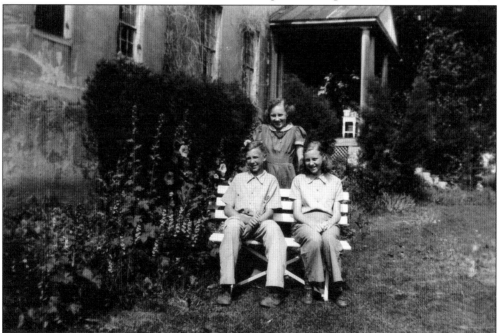

This June 1941 image shows, from left to right, Adam, Sybilla, and Mary Plummer with the front facade of the west wing of the mansion. Given the growth of the surrounding plants and shrubs, the photograph would have been taken near the end of spring or a cool, early summer day. (Markus Plummer.)

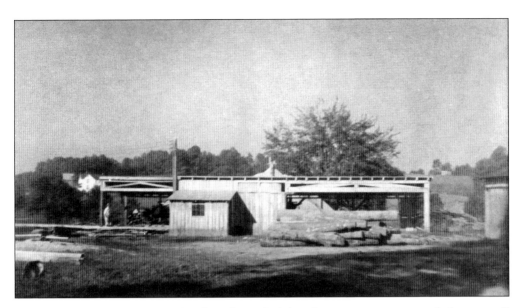

During the 1930s, the Plummer brothers diversified their business ventures to include a sawmill and lumber operation. At some point during their travels in the surrounding area, they discovered and purchased an old Geiser sawmill. The brothers then made a series of improvements to this device, rebuilding a portion of the wooden frame that had rotted away. William Plummer fitted the necessary castings and bearings to wooden frames that he designed himself. He also reconfigured power units from older truck engines, which were then used to power both the sawmill and the threshing machine they used for grain. These engines were salvaged from service trucks that used Buda and Wisconsin engines. These images show the sawmill as it existed in March 1946. Joseph Plummer is pictured below. (Markus Plummer.)

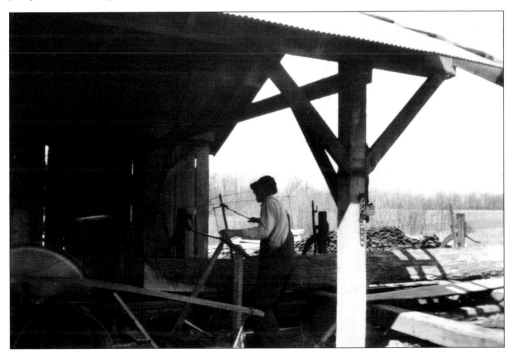

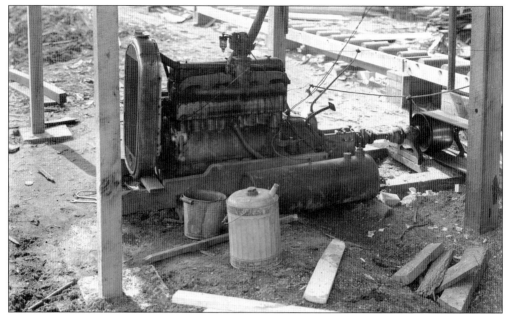

During this time, the Plummer sawmill came to the attention of representatives of the Baltimore Gas and Electric Company. Its unique method of power was one that they felt was worth memorializing. In addition, the company also saw in the Plummers a potential customer for electricity, which would power their sawmill much more efficiently. Starting in the late 1800s and continuing until 1980, Baltimore Gas and Electric would capture images (like these and those on the next page), as part of that company's daily operations. These images of Baltimore and the surrounding region show the changing commercial, cultural, and physical landscape of the region. These March 1946 photographs show the sawmill before it was powered by electricity. (Markus Plummer.)

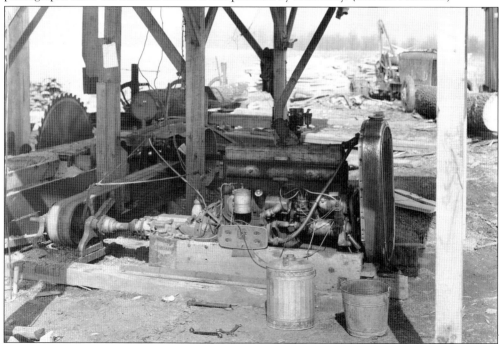

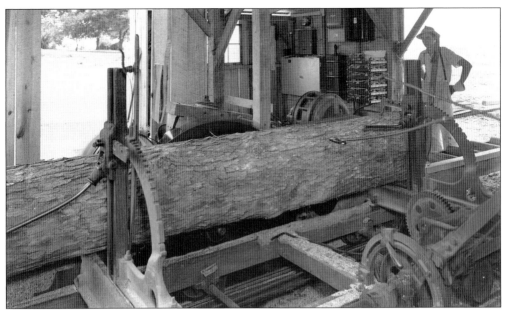

Several months later, in August 1946, employees of Baltimore Gas and Electric Company returned to the Plummer sawmill. By this time, the mill had been connected to the company's electrical grid and was no longer powered by gas engines. The milling business appears to have been ideally suited for both Plummer brothers. William had prior experience as a carpenter, while Joseph had worked as a sawyer, cutting lumber for some time. William ultimately gave up carpentry work and focused exclusively on the sawmill business. William Plummer also had experience as a mechanic, which certainly was put to good use when the brothers cobbled together their first gasoline-powered milling operation. William salvaged parts from old Army trucks and reworked them as needed for various projects. (Markus Plummer.)

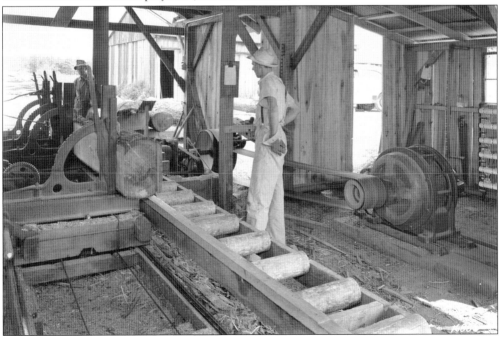

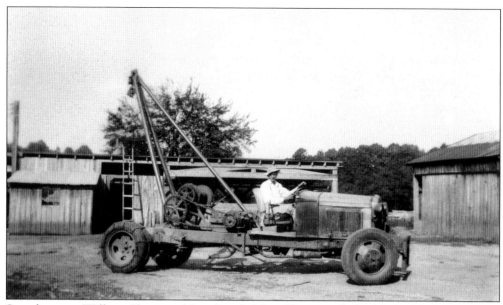

Seen here are William Plummer (above) and Adam Plummer (below). The Plummer milling operation proved to be quite successful. Indeed, it was in part because of this success that the Plummer family opted to move from Perry Hall Mansion. In 1948, the family completed a land swap with George and Ella Bryson. George Bryson owned a large property in Fallston, Maryland. He had attempted to use this tract for raising and training racehorses but found that the land was too rocky for this purpose. He suggested to the Plummers that his land would be well suited for the sawmill. The Plummers agreed and transferred their land to Bryson, with the latter also paying the $7,000 difference in property value. A sawmill continues to exist on the Fallston site to this day. (Markus Plummer.)

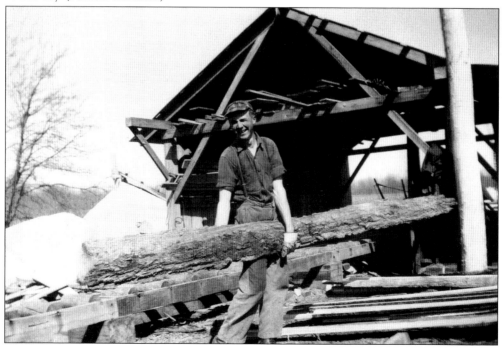

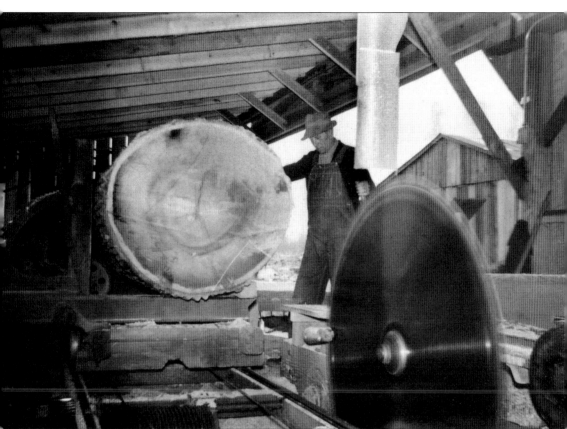

The Plummer family was certainly not alone when they made a venture into the sawmill business. According to information collected by local Perry Hall historian David Marks, such mills existed up and down the Great Gunpowder Falls and its nearby tributaries. Indeed, as was noted earlier, the Dunty family used a portion of their land at Perry Hall Mansion in order to run their own milling business. In addition to the Plummers, another large sawmill operation was owned and operated by the Fox family. This mill was located near what ultimately was referred to as the Sawmill Branch of the Great Gunpowder Falls. These and other mills were the principal suppliers of timber for use in the construction of various houses, outbuildings, and businesses in the growing Perry Hall community. Over time, these mills became more focused on providing specialty timbers or wood to be used as fuel for individual homeowners. (Markus Plummer.)

Above, from left to right, Sybilla, Eva, and Mary Plummer are seated inside in December 1946. Adam Plummer described the layout of their home as follows: "the walls of Perry Hall Mansion are situated on the points of a compass; (i.e. the north wall faced north, and so forth). The mansion had fifteen rooms, with 12 foot ceilings in the wing of the house and 16 foot ceilings in the main house with a fireplace in each room. There was a large staircase that began on the main floor by the Great Hall and continued for three levels. The hall measured 20" x 40" and had two entrances out to the porch. The porch itself began on the south side of the house, wrapping around the east and the north sides." The mansion is pictured below. (Markus Plummer.)

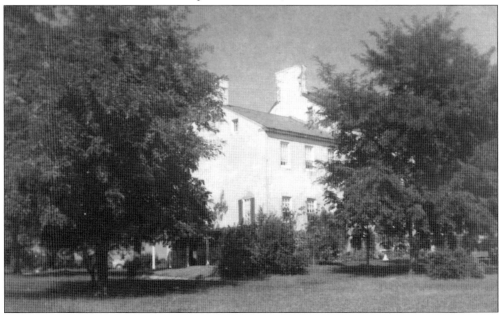

Eva and Mary Plummer are pictured above (and below with William) in September 1946. The Plummer family was particularly fond of going all-out for Christmas. William Plummer always put a great deal of effort into building a train garden in one of the second floor bedchambers. He would send Sybilla and her siblings down to the banks of the Gunpowder River to collect moss from the rocks that would be used as grass in the train garden. Plummer made a special effort during the World War II years to be sure that soldiers who were mustering at nearby Kahl's field received a personal invitation to visit Perry Hall Mansion and see his elaborate train garden. (Markus Plummer.)

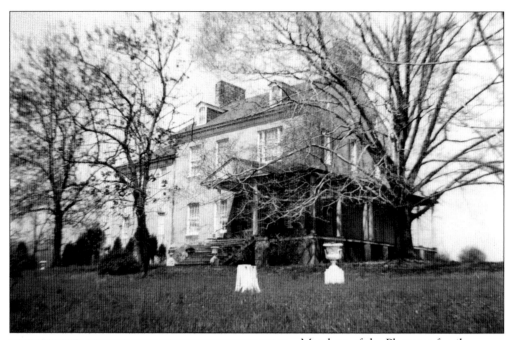

Members of the Plummer family recall a large spreading oak tree about 150 feet northwest of the house. They have speculated that its spread must have been close to 75 feet. As children, the younger Plummers were not permitted under this tree because it was hollow, and their parents feared the long, outstretched limbs would come crashing down on them. (Markus Plummer.)

Mary and Adam Plummer are pictured in June 1948. Less than six months later, the family left Perry Hall Mansion. However, as this account clearly indicates, the family's time in residence at the mansion left lasting memories. (Markus Plummer.)

In September 1945, Sybilla Plummer left Perry Hall Mansion and her family in order to attend nursing school. She graduated from the nursing program associated with St. Agnes Hospital, completing her studies in 1948, the year that her family left Perry Hall Mansion. She ultimately embarked on a long and successful career in the nursing profession. These c. 1949 photographs were taken at Easter, not long after her family moved from the mansion. The image on the right shows Sybilla standing alone; below, she is with her sister Mary. The outward appearance of the house, as seen in these photographs, is essentially the same as it was over a decade earlier. The pump house can be seen in the background of the image at right. (Sybilla Kramer.)

In an interview conducted for this book, Sybilla Kramer made note of the fact that one special treat her mother allowed the children was a swim in the nearby Great Gunpowder Falls. The mother accompanied the three youngsters, along with neighbors Paul and Matilda Lacey. This photograph shows the three siblings some years after their aquatic endeavors. (Sybilla Kramer.)

The Plummer children recall that their mother also made a valuable contribution to the launch of the sawmill. Adam (shown here) indicated that Eva Plummer visited the Enoch Pratt Free Library in Baltimore City to get books on how to build a sawmill in order to guide the efforts of her husband and brother-in-law. (Sybilla Kramer.)

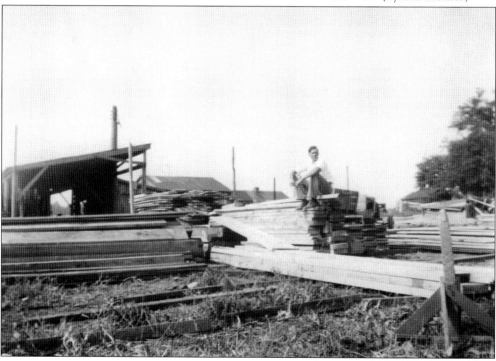

During a visit to Perry Hall Mansion, Sybilla Kramer, daughter of William and Eva Plummer, recalled her trepidation in venturing to the cellar. This large set of stairs leads up from the dirt floor of the basement. Visible at the center of the top stair is one of two iron eyebolts, part of the pulley system employed by the Goughs for lowering casks of wine into the cellar. (Sean Kief.)

Throughout Perry Hall Mansion, interior rooms have walls of plaster on lathe or masonry. This photograph shows the walls in the northeast room of the attic in the main house. (Sean Kief.)

Family members recall that at one time there was a large stove placed within the old ground floor fireplace, shown here with the Colonial-era hanging arm still in place. Eva Plummer would boil white linens on this stove. William Plummer boarded up the first floor fireplaces and used a stove for heating. Some bedrooms had open fireplaces, and on occasion, snow and birds would enter the house through the chimneys. (Sean Kief.)

This photograph shows Sybilla Kramer and her extended family during a visit to Perry Hall Mansion in 2012. Members of the Plummer family, especially Sybilla and her brother Adam, provided invaluable information with regard to what it was like to actually live in Perry Hall Mansion during the first half of the 20th century. (Sean Kief.)

Four

PERRY HALL MANSION IN THE 1950S

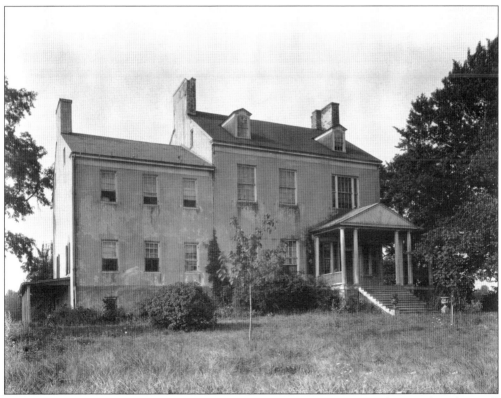

This image accompanied an article entitled "Perry Hall: Country Seat of the Gough and Carroll Families," featured in the March 1950 issue of *Maryland Historical Magazine*. Later that year, on November 2, 1950, Gordon and Katherine Smith purchased Perry Hall Mansion and nearly 23.5 acres of land from John and Mary Gontrum. (Maryland Historical Society.)

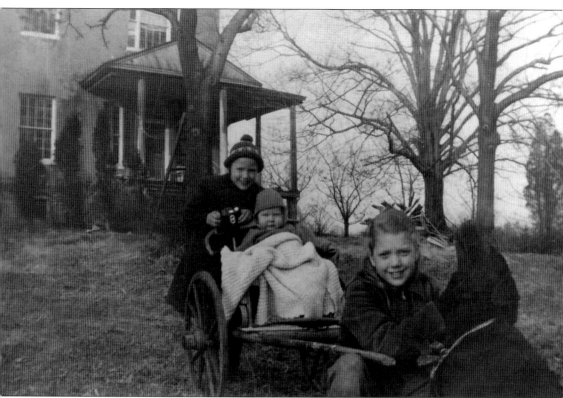

The Smiths had five children: Gordon Jr., Diana, Nancy, John, and Bruce. Katherine Smith's mother, Eva Schroeter Kane, also resided with the family. This 1951 photograph shows the children at play with one of the family's pet dogs. During the colder months, the Smith family principally used the west wing of the mansion, where there was reliable heat. At that time, there was no heat in the main part of the mansion, except for individual fireplaces in most rooms. Gordon and Katherine Smith used a bedroom in the main part of the mansion year round; the children would sleep there only during the warmer months. The Smiths were part of the burgeoning growth of the town of Perry Hall. Starting in the 1950s, scattered communities of single-family homes began to sprout up throughout the area. This trend would continue in earnest into the early 21st century. (Diana Smith Mister.)

In this late 1951 photograph, Diana and Nancy Smith pose in front of the west wing of Perry Hall Mansion as it appeared around the time of their father's renovation work. According to Diana Mister (née Smith), her father Gordon Smith was a very talented craftsman. He was a general contractor and would buy homes in need of improvement, conduct renovations, and then sell them. (Diana Smith Mister.)

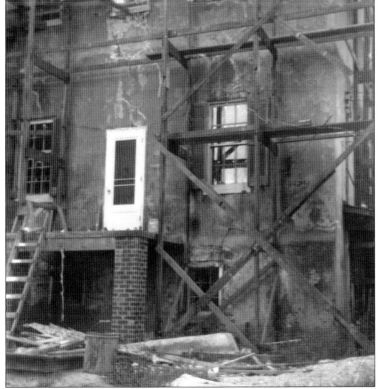

Gordon Smith and his father John Smith began working on a restoration of Perry Hall Mansion about six months after the family's initial purchase of the house. The Smiths began to put up the scaffolding shown here during the spring of 1951. They first completed the restoration of the back of the house, which served as the Smiths' main entrance to the wing of the mansion. (Diana Smith Mister.)

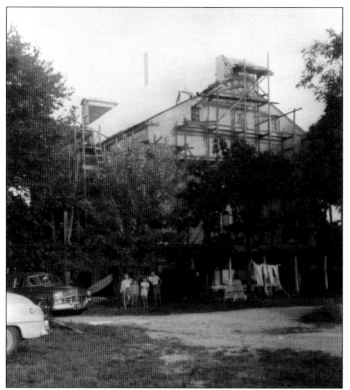

By the time the Smith family sold Perry Hall Mansion in September 1953, the exterior renovation work had been finished. Extensive repairs were completed to the brickwork, especially atop the chimneys, and all the exterior stucco had been repainted white, as opposed to the yellowish hue of earlier times. A number of outbuildings were either removed or substantially improved as well. Smith also added a circular portico to the end of the west wing. Present-day Perry Hall Mansion, as it appears to contemporary visitors, is largely the product of the work of Gordon Smith and his father John. (Diana Smith Mister.)

The five Smith children had a variety of options for fun and games during their days at Perry Hall Mansion. Diana Mister recalled recently that she and her siblings would occasionally play badminton in the dining room. She noted, of course, that these games were held prior to when her father conducted his work in that room, which included the installation of wallpaper and repairing the decorative plaster medallion and chandelier on the ceiling. Diana also remembered digging for gold in the wine cellar, while her brother Gordon would explore other parts of the cavernous basement. (Diana Smith Mister.)

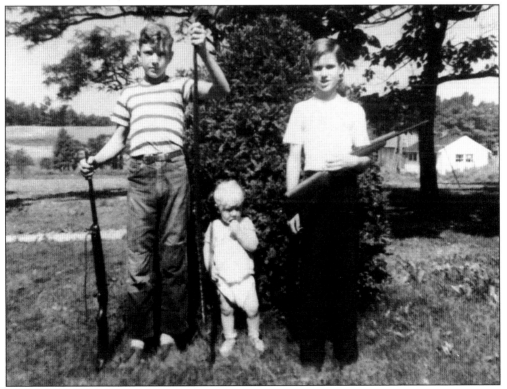

Gordon Smith built the cart above for use by the children. Ned, the family's pet long-horned goat, would be harnessed to this cart and would pull the Smith children around the mansion grounds. The Smith family also had a nanny and a billy goat. Diana Mister also noted fondly the times when she and her sister Nancy (right) would sneak down from their bedrooms and take quick peeks into the Great Hall during those occasions when her parents were entertaining guests. In later years, the structure that had once served as the Smith's chicken coop took on new life as the site of a puppet theater for the children. (Diana Smith Mister.)

The four school-aged children of Gordon and Katherine Smith are, from left to right, Gordon Jr., Nancy, Diana, and John. Gordon Smith eventually removed the old structure, shown here, which he replaced with a new chicken coop. Eggs from these chickens were used to augment other local purchases of fresh produce that added farm-fresh flavors to the Smith family's meals. (Diana Smith Mister.)

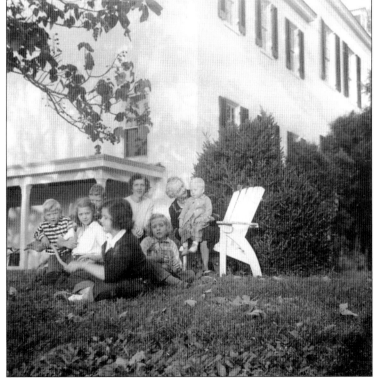

The entire Smith clan is gathered outside of Perry Hall Mansion. During the 1950s, the mansion and grounds were still at the center of a pleasant, pastoral setting. The Smiths could hold their family picnics or other outdoor functions with complete assurance of not being disturbed by the sounds of hustle and bustle nearby. (Diana Smith Mister.)

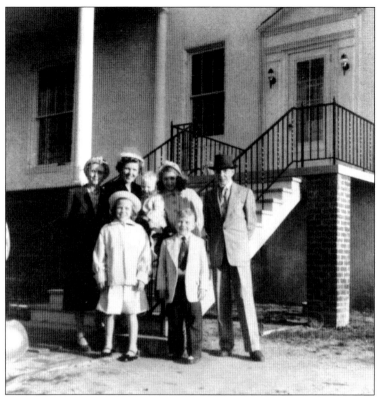

Above, the entire Smith extended family stands in front of the completed rear facade of the west wing. As can be clearly seen, the wraparound porch has been completely restored, as have the smaller porch and stairway leading to the entrance to the wing itself. Katherine Smith is surrounded by her children and mother. At right, Gordon Smith poses in dapper attire with Champ, the horse that was purchased for his daughter Diana. An old, somewhat dilapidated barn on the grounds was used to house Champ's stable. (Diana Smith Mister.)

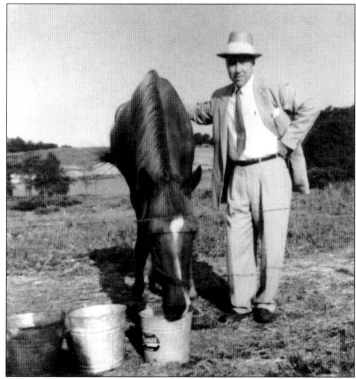

These images show the large, circular portico that Gordon Smith built onto the end of the west wing of Perry Hall Mansion. Over time, this structure served two distinct purposes. As the image on the right shows, the Smith family used the portico as a carport. Alternately, as seen below, the portico also provided a secluded porch area for outdoor entertaining. As Perry Hall Mansion is situated on one of the highest points in Baltimore County, it was wise to have a sheltered outdoor space for use in the event of a sudden thunderstorm. (Diana Smith Mister.)

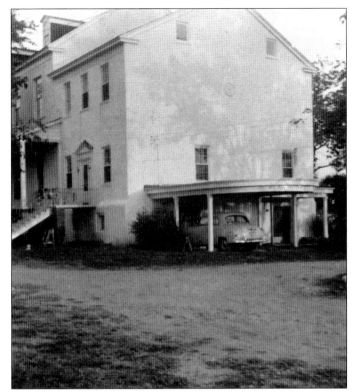

Diana Smith rides her horse Champ. The front facade of Perry Hall Mansion is clearly visible in the background. The exterior renovation work is substantially complete by this time as well, with both the stucco and shutters having been freshly painted not long before this photograph was taken. (Diana Smith Mister.)

Diana Mister recalls that her mother and grandmother would frequently pick mulberries and cherries from the surrounding trees. The two women would use these to bake pies for the enjoyment of the family after supper. She also remembers a wide variety of bushes, as well as huge pine, oak, maple, and fruit trees surrounding the house, with daffodils in bloom under the trees every spring. (Diana Smith Mister.)

Adjacent to the west wing of Perry Hall Mansion, Gordon Smith used a number of large stones to build two decorative structures. He created a faux well and also a stone grotto in close proximity to one another. The infant Bruce Smith is pictured with his grandmother while the well is being constructed. (Diana Smith Mister.)

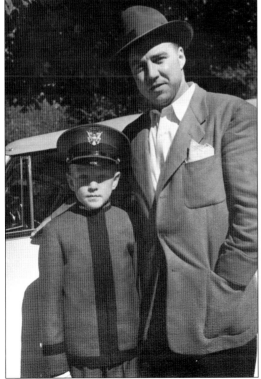

Shown here are Gordon Smith Jr. and his father. According to Nancy Smith, her father, Gordon, lowered Gordon Jr. down one of the chimneys in an attempt to open a faulty flue from the inside. Gordon was ten years old at the time. (Diana Smith Mister.)

One of the outbuildings at Perry Hall Mansion would have future significance for the Smith family. To the southwest of the main house was an old, dilapidated barn. Champ's stall was in the lower portion of this structure, where it was warmer and better sheltered from the elements. This structure had existed on the grounds of Perry Hall Mansion since approximately 1800. The foundation is consistent with that of the mansion and the former overseer's residence, which all date to the same period. Gordon Smith used large stones similar to those that made up the barn foundation when he constructed the faux well and grotto. It is believed that he found these stones on the outskirts of the property. In all likelihood, these stones were remnants of the foundations of other earlier outbuildings. (Diana Smith Mister.)

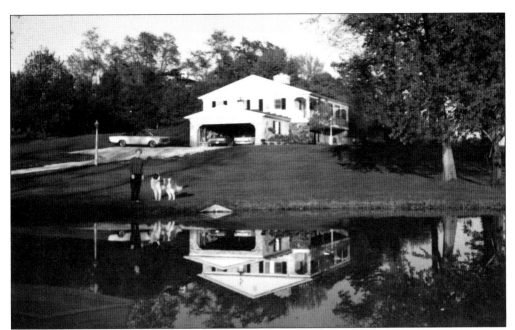

When selling Perry Hall Mansion in 1953, Gordon Smith opted to keep just over 18 acres of the original property. The barn mentioned previously was the only significant structure on this tract of land. This humble outbuilding was the site of Gordon Smith's next building project. He used the original stone foundation of the barn as the backbone for a new home. The pond shown above was dug along the path of a natural spring by Smith. These images depict the "barn house" as it appeared in the late 1960s. The house was featured in the May 18, 1969, issue of the *Baltimore Sun Magazine*. The family maintained ownership of this house and the surrounding property until March 1972. (Diana Smith Mister.)

THE MARYLAND TITLE GUARANTEE COMPANY—DEED IN FEE.

This Deed, *Made this* 1st *day of* September

in the year one thousand nine hundred and **fifty-three**, by and between, GORDON L. SMITH and

KATHERINE EVA SMITH, his wife, of Baltimore County, in the State of Maryland, parties

of the first part; and BENJAMIN H. KAESTNER and MABEL G. KAESTNER, his wife, of Baltimore

County, in the State of Maryland, parties of the second part.

Witnesseth, *that in consideration of the sum of* Five Dollars, ($5.00) and other good

and valuable considerations, the receipt whereof is hereby acknowledged, the said parties

of the first part do hereby grant and convey unto the said parties of the second part as

tenants by the entireties, their assigns and unto the survivor of them, his or her- - - -

After completing a significant series of renovation projects at Perry Hall Mansion, Gordon and Eva Smith sold the property in September 1953. The buyers were Benjamin and Mabel Kaestner. This deed shows the particulars of the transaction. It is interesting to note that one of the Internal Revenue Service tax stamps (far left) features a portrait of earlier mansion owner William Meredith. (Baltimore County.)

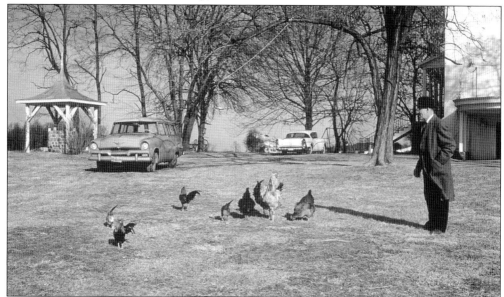

Benjamin Kaestner made his living as an installer of stainless steel kitchens and fixtures. Surviving neighbors from this time recalled episodes of the elder Kaestner helping out by performing similar work in their own homes. On those occasions when the Kaestners were not busy working, their children and grandchildren would frequently visit. (Kaestner family.)

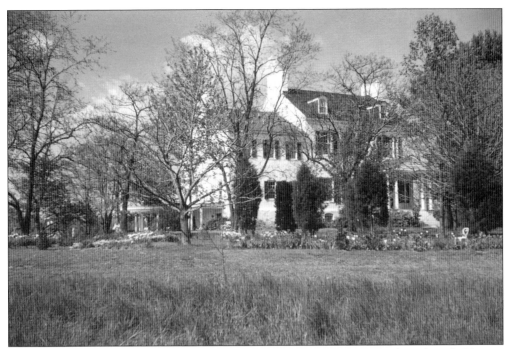

At the time of sale, Gordon and Katherine Smith opted to maintain ownership of nearly 20 acres of land that they had purchased in 1950. As a consequence, the Kaestners became the owners of slightly less than four acres of property in the immediate vicinity of Perry Hall Mansion. Over the course of the previous 100 years, the land associated with the home had been greatly diminished. In comparison, at the time of Harry Dorsey Gough Carroll's resurveying of the property in 1847, Perry Hall Mansion was at the center of a 1,344-acre estate. (Kaestner family.)

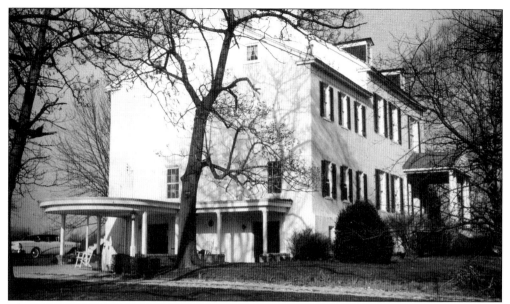

The house that the Kaestners moved into in 1953 was in better condition than it had been for some time. Significant exterior repair work had been completed by Gordon Smith as well as the installation of a modern kitchen and bathroom within the interior. Accounts from the time indicate that the Kaestner family focused on making a series of cosmetic improvements to the interior rooms. (Kaestner family.)

One of the Kaestners' five grandsons is pictured in front of the only outbuildings that remained on the property after 1953. These two adjoining sheds were completed by Gordon Smith, ostensibly to house the tools and other equipment that would have been required for his refit of Perry Hall Mansion. Remnants of these structures survive on the grounds of the mansion to this day. (Kaestner family.)

In interviews for this account, the Kaestner grandchildren offered numerous stories of their weekend visits to grandfather and grandmother Kaestner's house. These images show just some of the leisure-time activities available for youngsters who visited Perry Hall Mansion. The children would explore the nearby woods and generally enjoy the outdoor surroundings as they and their parents lived in Baltimore City at that time. The backyard grotto, originally built by Gordon Smith, also doubled as a small swimming pool. As the boys got older, they designed a series of four golf holes, complete with small, aluminum holes in the center of closely cropped sections of grass, meant to serve as golf greens. (Kaestner family.)

The Kaestners were undoubtedly quite proud of the interior design work that took place during their residency at Perry Hall Mansion. During the late 1950s, an extensive series of photographs were taken, offering various views of nearly every room within Perry Hall Mansion. These images and those on the opposite page show the Great Hall as it appeared during the Kaestner years (1953–1966). These photographs were taken from different vantage points of the elaborate murals that were featured on each of the walls. The room itself is 20 by 40 feet with 16-foot ceilings. A large fanlight is positioned over the south entrance; a matching fanlight at the north entrance was stolen at some point during the early 1920s when absentee landlords served as owners of the home. (Kaestner family.)

Mabel Kaestner coordinated the interior design and furnishing selections for each room of the mansion. For the Great Hall, she opted to decorate the room with a variety of elegant empire and Victorian sofas and occasional tables. One armchair that dated to approximately 1700 had originally belonged to the Cadwalader family of Philadelphia. General John Cadwalader, commander of Pennsylvania troops during the Revolutionary War, eventually relocated to Talbot County, Maryland. Alongside one wall of the Great Hall, the Kaestners had a square antique Steinway piano. The wide-plank pine floor was offset by a series of colorful, matching oriental rugs. (Kaestner family.)

Two formal rooms have always been present to the immediate west of the Great Hall. Facing the front of the house was a room that historically had functioned as a parlor, but was used by the Kaestner family as a dining room. Given its proximity to the upstairs modern kitchen that had been added in the early 1950s, converting the space to a dining room was a practical decision. This room also appears on the opposite page. Offsetting the Greek revival trim and molding were red curtains and wallpaper displaying a gold and silver damask design. Various early American family portraits adorned the walls. Silver candelabra sat atop various pieces of furniture throughout the room. (Kaestner family.)

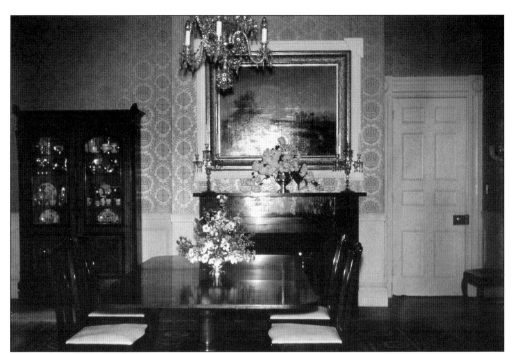

At the center of the Kaestner dining room was a medium-sized, two-leaf Duncan Phyfe–style table with six chairs. Additional furnishing consisted of a sizeable sideboard that was purchased from the Davidson family, owners of Cremona (c. 1819), one of the largest surviving Federal-style houses in St. Mary's County, Maryland. An upright china closet stood to the left of the fireplace, and a small chest of drawers was placed between the two front windows. An avid florist, Mabel Kaestner adorned most of the rooms in the house with her own flower arrangements. For the holidays, elaborate arrangements would be placed on the mantelpiece in the dining room. (Kaestner family.)

Mabel Kaestner opted to paint the walls of the music room a shade of pale pink, offset by white trim. An Empire-style sofa, butler's desk, birdcage table, and occasional chairs were used to furnish the space. A pale grey Chinese rug with royal blue figures covered the floor. The Goughs would have certainly approved of the blue Staffordshire china used to accent the room. (Kaestner family.)

The Kaestners used this room in the west wing as a sitting room. Alternately, it served as a dining room for other residents of Perry Hall Mansion. This image provides an excellent view of the Adam-esque wooden mantelpiece. On the front of the mantle are ornate carvings showing an urn in the center, with cherubs and a dog and goat on either side. (Kaestner family.)

These 1963 images show the construction of one of the houses in a subdivision that was eventually developed on land surrounding the remaining mansion grounds. This particular house was built for Kenneth and Sharon Smith, descendants of earlier Perry Hall Mansion residents, the Dunty family. Today's Perry Hall Manor community consists of well over 100 homes situated on six different streets to the north and east of the mansion. Many of the original residents of these homes continue to live in the community. Consequently, neighbors have had numerous opportunities to interact with members of the three different families that resided at Perry Hall Mansion over the years. (Kenneth Smith.)

When selling the mansion and 23.5 acres of land in 1950, then owner Judge John Gontrum, shown in this portrait, held onto around 180 acres of property that had been associated with the parcel when he originally purchased it. He subsequently subdivided this acreage for development into the Perry Hall Manor residential community. (Baltimore County.)

In early 2009, Hank and Reed Kaestner, two of the grandsons of Benjamin and Mabel Kaestner, had the opportunity to visit Perry Hall Mansion. Neither Kaestner had been to the home since their grandparents sold the property in 1966. Their visit provided an excellent opportunity to build on the oral history collection that has enriched this account. (Sean Kief.)

Five

MODERN PERRY HALL MANSION

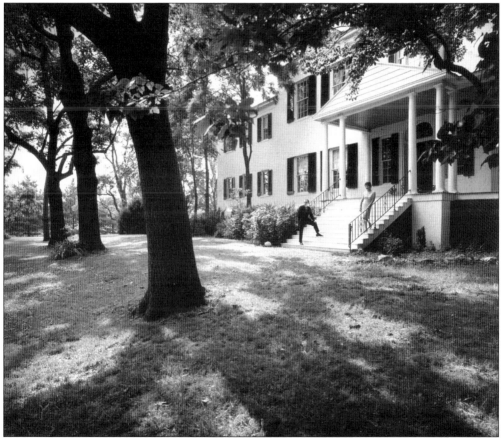

On October 5, 1966, the Kaestners sold Perry Hall Mansion to Thomas Mele Sr. and his wife, Marjorie (seen here). Prior to moving in, the Meles spent roughly one year overseeing extensive interior and exterior repairs. The couple hired the H.L. Chambers Company from Baltimore to supervise the repairs. (*Baltimore Sun.*)

As a graduate of the Maryland Institute College of Art, Marjorie Mele (shown standing in the parlor) was well suited to the task of coordinating the interior redesign of Perry Hall Mansion. Thomas Mele Sr. served as president of Mele Metal Fabricators. Both he and his son Thomas Mele Jr. were accomplished photographers. The younger Mele would later inherit Perry Hall Mansion, owning it until 2001. (*Baltimore Sun.*)

Marjorie Mele's artistic ability spanned many fields, as she was both a composer and pianist. This photograph shows the Mele music room. She also was proficient as a painter. Over her time in residence at Perry Hall Mansion, she completed a number of scenes of the grounds, which were hung in the kitchen and dining area of the house. (*Baltimore Sun.*)

By the fall of 1969, the improvements undertaken by Thomas and Marjorie Mele were substantially complete. The work attracted the attention of a reporter for the *Baltimore Sun Magazine*, Joann Harris. Harris prepared a profile of Perry Hall and the Meles' improvements that ran on July 20, 1969. This and the two prior interior photographs show the results of their work. The Great Hall is pictured here during the tenure of the Mele family. Marjorie Mele elected to furnish this room in a Chinese style, using ornately carved tables, chairs, and china closets throughout the room. She used a series of five burgundy-colored oriental rugs to cover the pine flooring. Pale green patterned wallpaper was hung, surrounded by the original accent molding, which was painted white. Oriental-themed vases and porcelain pieces were displayed on the mantle of the fireplace on the east wall. (*Baltimore Sun.*)

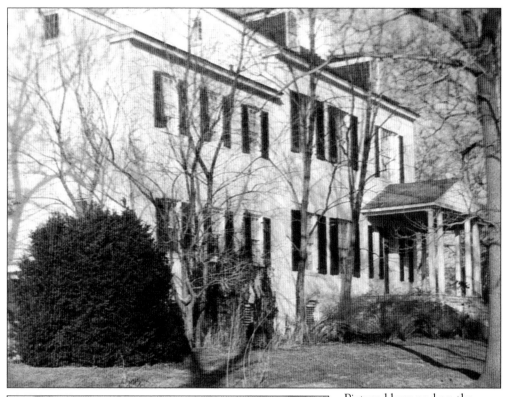

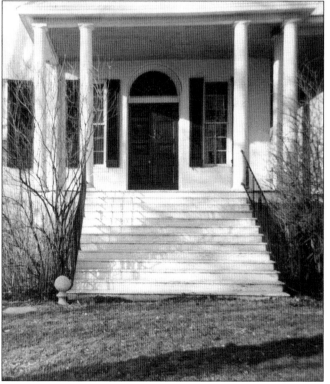

Pictured here and on the opposite page is the house in 1968, around the time that the first series of renovation work was being completed for the Mele family. As can be seen, a white coat of paint had recently been applied to the stucco on the exterior walls. During the time that Perry Hall Mansion was being improved, the Meles continued to live in their townhouse in Baltimore's Mount Washington neighborhood. Marjorie Mele was drawn to the mansion because of its significant place in the history of Maryland. Prior to the purchase, she spent a great deal of time researching the history of the home in preparation for the couple's anticipated restoration project. (Casey Phillips.)

This image shows the back of Perry Hall Mansion, facing its northeast corner. The wraparound porch, pictured here, was later replaced by the Meles after damage incurred during the winter of 1976. The original design of the Great Hall was very beneficial for regulating the temperature of the room, as each end has a large set of central entrance doors that could be opened for ventilation. (Casey Phillips.)

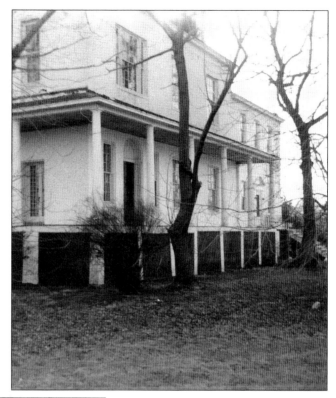

In honor of our nation's bicentennial in 1976, students at Perry Hall High School opted to highlight their community's connections to the Colonial era. As shown here, the cover of the yearbook for the high school's class of 1976 featured an image of Perry Hall Mansion that was taken sometime during the 1950s. (Denise Shifflett.)

Teachers and administrators of Perry Hall High School have cultivated the links between the school and the historic home that was the source of its name. As this image shows, graduates of Perry Hall High School are always reminded of the mansion, as engravings of both the house itself, as well as the Gough family crest, are featured on class rings for the school. (Baltimore County Councilman David Marks.)

Beyond its place on class rings, the Gough family crest has also been on prominent display within Perry Hall High School. This plaster representation of the crest hung inside the main lobby for many years. In recent times, the crest has been featured on the changeable copy sign located in front of the school as well as above the vestibule as one enters the main doors. (Perry Hall High School.)

In 1999, Thomas Mele Jr. indicated his desire to transfer ownership of the house and grounds to a person or organization interested in historic preservation. In response, community leaders worked collaboratively with elected representatives for Perry Hall at the state and county levels. These deliberations culminated in Baltimore County government's purchase of Perry Hall Mansion in November 2001. Initial work included an architectural and structural survey of the building and the compilation of an initial plan for a multiphase renovation of the house itself. These schematics were completed as part of the survey of the building and grounds and show the floor plan of the house as it has existed since the 1840s. (Baltimore County.)

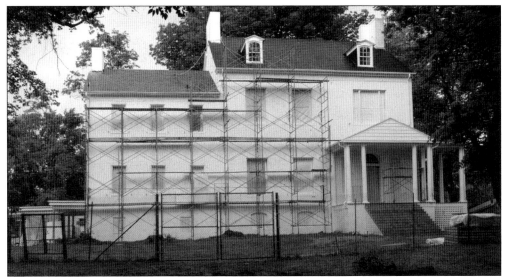

During the winter of 2003–2004, extensive exterior repair and restoration work was performed at Perry Hall Mansion. Renovations included replacement of the rear stairs and railing, roof, support columns and posts, front porch steps, gutters and downspouts, and exterior trim, louvers, and lattices. The exterior stucco was also replaced and the exterior repainted. Interior improvements, including electrical and plumbing, were undertaken in 2009. (Sean Kief.)

In 2007, Historic Perry Hall Mansion Inc. was established in order to preserve and promote this locally significant property. Since then, the organization has conducted many activities meant to broaden public understanding of this historic residence, to raise funds in support of its ongoing preservation and restoration, and to gather the community for seasonal events. This image shows an April 2008 cleanup of the mansion grounds. (Jeffrey and Patricia Smith.)

In October 2008, Historic Perry Hall Mansion hosted its first public tour. Planned jointly with the Maryland Historical Society (MdHS), Perry Hall Mansion was featured as part of the society's annual tours of historic homes. In this photograph, then MdHS executive director Robert Rogers (far left) participates in the unveiling of a 19th-century clock once belonging to the Gough family, which was acquired for display at the mansion. (Christopher Becker.)

A significant element of the mission of Historic Perry Hall Mansion has been to broaden community awareness of this important cultural resource. The organization has hosted tours, as seen here, for a variety of organizations and other interested parties. In addition, members of the group have given informational lectures for local civic groups and have had a regular presence at community fairs and festivals. (Sean Kief.)

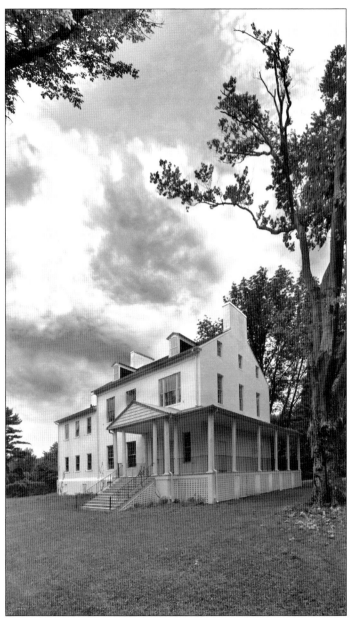

Most recently, Baltimore County government has expressed its wish that ownership of Perry Hall Mansion should be more closely connected to the people. To that end, representatives of the county have been actively engaged in the process of shifting ownership and long-term responsibility for this historic home from the government directly to Historic Perry Hall Mansion. In this age of limited government resources, it is clear that a volunteer, community-based organization has greater flexibility in doing what is necessary for a historic home like Perry Hall Mansion to prosper and flourish. Moreover, over the course of the organization's existence, Historic Perry Hall Mansion and its dedicated leadership and members have gained a solid understanding of what needs to be done to achieve such important goals. The organization will continue to do what it takes to ensure that the history of Perry Hall Mansion continues to be a vibrant one, now and into the foreseeable future. (Christopher Becker.)

BIBLIOGRAPHY

Bevan, Edith Rossiter. "Perry Hall: Country Seat of the Gough and Carroll Families." Baltimore, MD: *Maryland Historical Society Magazine*, Vol. 45, March 1950, pp. 33–46.

Carroll, Harry Dorsey Gough. *Ledger and Family Accounts, 1827–1844*. Maryland Historical Society, MS 400, Box 2.

Clark, Elmer T., ed. *The Journals and Letters of Francis Asbury, in Three Volumes*. London, England: Epworth Press/Abingdon Press, 1958.

"Family Bible of Harry Dorsey Gough Carroll." *Maryland Historical Society Magazine*, Vol. 22, No. 4, December 1927, pp. 377–380.

Harris, Joann. "A Family that Moved 23 Times." Baltimore, MD: *Baltimore Sun Magazine*, May 18, 1969.

Lacey, Matilda C. *Perry Hall: So Called Since 1775*. Perry Hall, MD: Perry Hall Improvement Association, 1970.

Marks, David. *Crossroads: The History of Perry Hall, Maryland*. Baltimore, MD: Gateway Press, 1999.

McGrain, John W. and Louise K. Lantz. *Perry Hall*. Washington, DC: National Register of Historic Places documentation. US Department of the Interior, National Parks Service, 1978.

"Perry Hall Mansion: A Gracious Monument to Maryland's Past." *Bel Air Road Booster*, July 12, 1962, p. 12.

"Perry Hall: Sister Mansion of Hampton House." Baltimore, MD: *Baltimore Sun Magazine*, July 20, 1969, p. 22.

Short, Kenneth M. "Perry Hall: Maryland Historical Trust—Maryland Inventory of Historic Properties Form." Crownsville, MD: Maryland Historical Trust, 2003.

"Something of Perry Hall, Where Methodist Heroes Met in Days Long Gone." Baltimore, MD: *Baltimore Sun*, October 30, 1921, p. 2.

ABOUT THE ORGANIZATION

Historic Perry Hall Mansion Inc. was founded in 2007 for the purpose of maintaining, managing, and promoting the Perry Hall Mansion, a historic property in Baltimore County, Maryland. The organization supports the use of property as an educational resource reflecting the area's history and culture, showcasing the contributions of the house and its residents to Maryland and United States history. Historic Perry Hall Mansion also helps to facilitate the use of the house as a repository for artifacts relating to local history. The house is available for public use, including tours and events. For additional information, please visit the organization's website: www.perryhallmansion.org.

Discover Thousands of Local History Books Featuring Millions of Vintage Images

Arcadia Publishing, the leading local history publisher in the United States, is committed to making history accessible and meaningful through publishing books that celebrate and preserve the heritage of America's people and places.

Find more books like this at
www.arcadiapublishing.com

Search for your hometown history, your old stomping grounds, and even your favorite sports team.